CELTIC CRAFTS
THE LIVING TRADITION

CELTIC
CRAFTS
THE LIVING
TRADITION

DAVID JAMES

BLANDFORD

This book
is dedicated
to my sons,
Emrys, Aidan and Chiron

A BLANDFORD BOOK
First published in the UK 1997 by Blandford
A Cassell Imprint
Cassell plc, Wellington House,
125 Strand, London WC2R 0BB

Copyright © 1997 Cassell plc
Text copyright © 1997 David James
Illustrations and photographs copyright as credited

Distributed in the United States by Sterling Publishing Co., Inc.,
387 Park Avenue South, New York, NY 10016–8810

A Cataloguing-in-Publication Data entry for this title is available from the
British Library

ISBN 0-7137-2663-6
Designed by Richard Carr
Jacket Design by Jamie Tanner
Printed and bound by Colorcraft, Hong Kong.

CONTENTS

ACKNOWLEDGEMENTS

Special thanks to Grace for her loving support while producing this book. Also to Stuart Booth, my publisher, for helping the idea of the book to become a reality, and to Devi for her kindness and support during the years we spent in Argyll and Dorset. Likewise for the ongoing support of my family, especially Mada, my mother.

Special thanks also to Shakti Genaine of the C.I.E. arts/meditation/ecology community in Spain; to Kora Wüthier, Celtic harpist and organizer of the annual Celtic festival at Lake Constance, Switzerland; and to Mike Kirschenbaum of Santa Monica, California, for their continued support and appreciation of my work.

Grateful thanks to all the contributing craftworkers in the book for their friendly cooperation, along with their fascinating stories and fine photographs. May your work, and quality Celtic craftwork everywhere, continue to flourish and give pleasure to many people.

PHOTOGRAPHS AND ILLUSTRATIONS

Photographs in each section are the copyright of that particular craftsperson with the exception of the following:

frontispiece: sunrise over the Orkney Isles - Helen Adams; p.12: Celtic gold stater - Michael Dudley; p.29: Callanish stone circle, p.37: Stones of Stenness, p. 57: Pictish Sueno stone - courtesy of Mrs Hazel Glaister; p.32: Pete Rowland at work - Richard Welsby; p.61: Mike Davies at work - courtesy Mike Davies Welsh Lovespoons; p.74: Lonan cross - Harold Costain Roberts; p. 87: Iron Age round house - Simant Bostock; p.105: Lindisfarne Carpet - Karen Mundy; p.111: Annie Wealleans at work - Michelle Williams; p.113: Celtic beads - Paul Bevan; p.8: author's farmhouse, p.117: St Brynach window, p. 132: St David's Cathedral - David James

PREFACE

I HAVE BEEN ACTIVELY involved in the world of arts and crafts for over thirty years, and for twenty of those years I have concentrated on the Celtic art form and its application to a wide variety of crafts.

I first became interested in the Celtic art form when I was eighteen years old. I spent a winter living and working with the Iona Community in the Inner Hebrides, and I was given the job of relabelling the ancient carvings in the museum on the island. That was where I first came into contact with Celtic designs, some of which had been created over a thousand years before. Their intrinsic beauty made an immediate impression on me, and the love of this ancient and fascinating art form is still with me, more than thirty years later.

In 1976 I went to live in Kintyre in western Scotland. This was an ideal place to further my interest in Celtic art and crafts, and it was there that a kind librarian in Campbeltown lent me copies of George Bain's books, which had been written in the 1920s for Scottish school children. Years later these books, with additional material, became the single volume that is so popular with Celtic artists and craftspeople today, *Celtic Art: The Methods of Construction*. After reading the original books and experimenting with the methods involved, I was well and truly hooked.

Today, twenty years later, after applying Celtic art forms to a variety of crafts, as well as producing original colour paintings for cards, calendars and posters, I write books on the history of the Celts and am also the editor of the magazine *Celtic Connections*. This venture was begun in 1992, with a great deal of enthusiasm, some favourable publicity from the Welsh Tourist Board and a battered old electric typewriter. The idea for the magazine came from a dear friend, Grace, who has been a constant source of inspiration since its inception. Now, four years later, the magazine

has subscribers all over the world, from Norway to Japan, from New Zealand to the United States. As well as delving into the history of early Celtic sites and carvings from Ireland to Brittany, the magazine concentrates on Celtic arts and crafts in many different media, and it has become one of the main places in which Celtic artists advertise their work. Each issue features a specific craftsperson working within the Celtic tradition, and I first became acquainted with many of the high-quality craftworkers, whose creations are presented in this book, through their involvement with the magazine. Although the main inspiration lies within the Celtic countries, there are practising Celtic craftworkers worldwide, especially in the United States and Canada. Many of these craftworkers find inspiration and impetus for their work by returning whenever possible to Celtic lands and their relatives who still live in these countries.

I hope that this book will convey to readers some of the delight experienced in the creation of Celtic crafts and the application of the Celtic art form to different craft media. I have yet to meet a practitioner who is not totally entranced by the beauty of these designs, whether they be representations of the pre-Christian La Tène style, patterns based on the great illuminated Gospels, such as those of Kells and Lindisfarne, totally original and new designs created from first geometric principles, or designs directly inspired by early artefacts. This feeling of wonder is conveyed through their work, and throughout this book many exquisitely beautiful and inspiring Celtic creations will be found.

I would like to apologize to all those craftworkers whom I have not been able to include in the book, purely through lack of space. These include individuals and centres from the Shetland Isles to Nova Scotia in Canada, who have sent details and photographs of their work. To Celtic craftworkers everywhere who are continuing the tradition, may your fine work continue to give pleasure to many people, as well as bringing beauty and pleasure to the world at a time when it is much needed.

David James
Waddon, Portesham, Dorset

The author's farmhouse in Argyll, Scotland, overlooking the Mull of Kintyre.

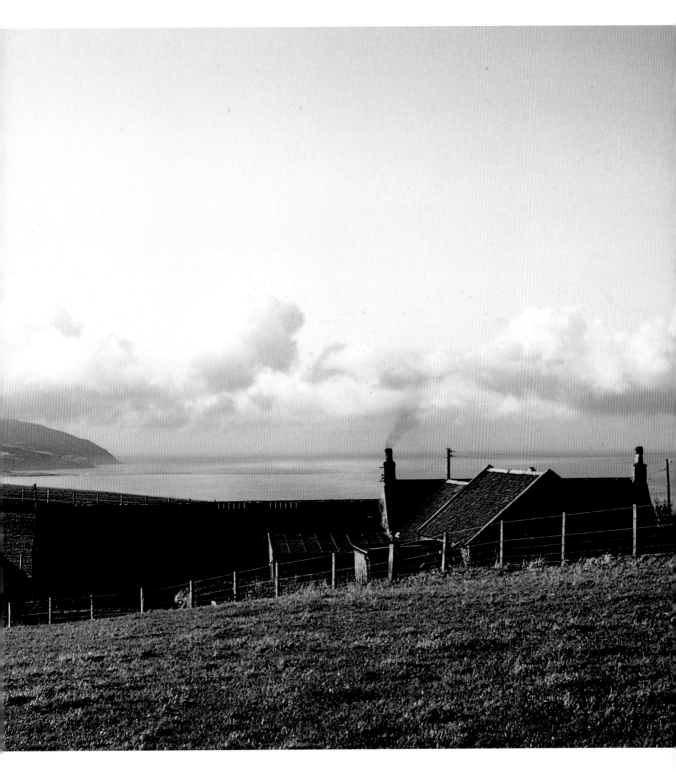

INTRODUCTION

EFORE LOOKING AT the different ways in which the art of the Celts is interpreted today, perhaps we should look at exactly who these people were and what is known of their origins. Like myself, you may have been one of those people who were taught at school about 'those barbarians from Europe who invaded Britain before the Roman conquest'. When I look back on my schooldays, I feel sorry for my history teacher – his misinformation deprived himself (and his pupils) of a world rich in mystery, legend, tales of warfare, heroism, gods and goddesses, ingeniously constructed fortifications, buildings and earthworks, and, possibly the most important of all, a wondrous legacy of craftwork.

So what of the Celts themselves and their origins? The Ancient Greeks knew them as Keltoi (hence the name Celt). Their lifestyle, as recorded in Classical writings, was nomadic and aggressively warlike. They were tribal peoples, fighting among themselves as well as with the occupants of the lands they invaded. The earliest archaeological evidence of the Celts comes from what is known as the Hallstatt era, named after a salt-mining region in Austria. From at least 700 BC, and probably considerably earlier, the Celts roamed about this region. Moving westwards, some of them occupied an area of Switzerland on the shores of Lake Neuchâtel from the fifth century BC onwards, and this region gave rise to the stylized La Tène art form. Many beautiful artefacts from this period, made from precious metals, bronze and enamel, have been discovered throughout Europe and further east and can be seen in museums worldwide.

The Celts were fearless fighters. Not only were they the inventors of that powerful and ingenious vehicle, the chariot, but their horsemanship was unsurpassed, too. They venerated the horse in the form of the horse-goddess Epona, and after the Romans had conquered the Celts on mainland Europe and, later, in Britain,

they adopted the Celtic custom of using the horse, with or without a chariot, on some of their coinage as a symbol of respect for the horse and its use in warfare.

Not content with a sedentary lifestyle, the Celts journeyed further afield, invading Rome itself in 390 BC and Delphi in Greece in 279 BC. Some even travelled into Galatia in Asia Minor and settled there. In response, the Roman Empire mounted a renewed series of attacks on the Celts, driving them up through Gaul (now France) and finally forcing the remaining Celts across the sea to Britain. Even Julius Caesar, whose might was well known, had difficulty in defeating the Celts. He was genuinely intrigued by their ingenuity and talent and wrote fascinating sketches of their superiority in horsemanship and chariot warfare, boat-building and other skills in *De Bello Gallico* ('The Gallic Wars').

Given this emphasis on warfare, one might wonder where crafts featured in the lives of the Celts. The Classical writings that are extant depict the Celts as a very extrovert people. (One cannot call the Celts a 'race', as there were many different tribes and much interbreeding with different European cultures.) This extrovert character was manifest in everything they did, and Classical writers of the time describe how they wore multi-coloured clothes and adorned their horses with beautifully crafted bronze decorations. Among these decorations was an item called a *champfrein*, which was a finely constructed, protective bronze mask for the horse's head, sometimes incorporating two 'horns' on which to impale victims in battle. Examples of these still survive. Bronze spear-tips, shields and swords, and personal adornments, such as buckles, brooches and gold torques, were constructed to show that they were a superior people and a force to be reckoned with.

Celtic crafts at this time certainly were superior, and their skills in metalworking were superb. All the equipment required to produce fine bronze and gold artefacts, including enamelled pieces, could be easily carried from place to place in a sizeable chariot. This portability made possible the unlikely combination of aggressive warfare and fine craftwork, as is testified by the numerous magnificent examples of their crafts that can be seen in museums today. In Europe, artefacts from the fifth century BC onwards have been discovered, including cast bronze heads, exquisite sculptures in bronze of boars and other animals,

enamelled horse-brasses, decorated bronze helmets, cast bronze and clay replicas of chariots, fine gold coinage… the list goes on. Caesar himself in *De Bello Gallico* notes that the main obsessions of the Celts were 'cattle and gold' (being gold in colour, bronze was presumably included with gold). It would seem that both these commodities in their individual ways fitted in well with the itinerant lifestyle of the Celt.

During the second century BC the Roman occupation of Gaul forced the Celts in that country to cross the sea to Britain. Large numbers were involved in this forced exodus. If you asked many people today about the Celts and where they originally lived, the majority might suggest Wales, Scotland, Cornwall or Ireland. It should be noted that from the second century BC until the time of the Roman invasion of AD 43 approximately thirty-three recorded separate Celtic tribes were living in Britain. Among these were the southern tribes of the Atrebates and Catuvellauni, based around Silchester and St Albans respectively, the Brigantes of the Humber estuary region, the Iceni of Norfolk, whose queen Boudicca is well known, and the Durotriges, who occupied Dorset and west Hampshire. It can be seen by the wealth of fine pieces of craftwork discovered in these areas that the creative tradition of the Celts flourished at this time. Enamelled bronze harness decorations, a number of engraved bronze mirrors and Celtic gold and silver coins, some of which were made in baked clay moulds, are just a few of the wonderful items of craftsmanship from this period in Britain. A fine engraved Celtic bronze mirror of the first century BC was discovered by an enthusiast with a metal detector not more than three-quarters of a mile from where this book was written, near Portesham in Dorset. It is now in Dorchester Museum.

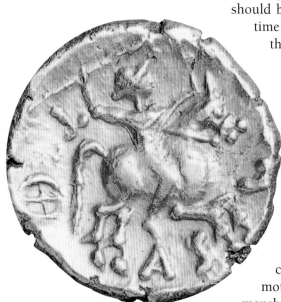

Celtic gold stater, made in southern Britain and dating from 20–10 BC, during the period of the ruler Tasciovanus.

The coin illustrated is a Celtic gold stater from the period of the ruler Tasciovanus, made in southern Britain and dating from 20–10 BC. The figure on horseback has a war-trumpet in his raised hand.

The main legacies of the Celts today by way of constructed earthworks are the massive Iron Age hillforts that can be found throughout southern Britain. Although some of these sites were

occupied mainly for agricultural purposes prior to their arrival, the massive defensive ramparts and ditches were constructed by the Celts themselves. The largest example in Europe is at Maiden Castle, near Dorchester, Dorset, which has an inner area of about 40 acres. One of the most visually spectacular locations for a hill-fort is Pilsdon Pen in west Dorset. 'Don' or 'dun' is the Celtic word for hill; the same word is used in Scots Gaelic.

After the Roman invasion of Britain those Celts who remained alive were scattered, and many of the women were forced to inter-breed with their captors. Most of the tribes, therefore, apart from the very remote ones, were dispersed. It is at this point that we turn to an entirely different aspect of Celtic history and traditions of craftwork.

Pilsdon Pen Iron Age hillfort, west Dorset.

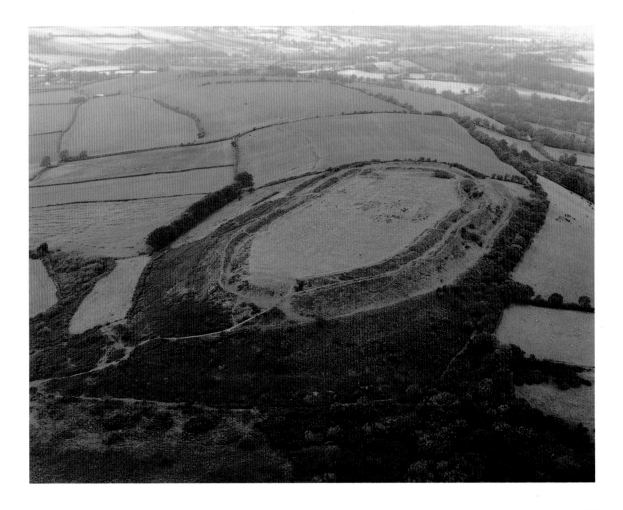

During the first millennium BC there was a recognized tin trading route, the Phoenician trading route, between the Near East (predominantly Egypt and Greece) and Britain (Cornwall), which was then known as the Cassiterides (from the Greek word *kassiteros*, meaning tin). It is thought that during the first century AD Joseph of Arimathea travelled by this route to Britain and founded the first Celtic Christian church at Glastonbury, Somerset. Some legends postulate that Jesus himself visited Britain in this manner, although there is no evidence for this. Soon after the coming of Joseph to Glastonbury, Celtic Christianity began to take root in Ireland. It seems probable that the original Celtic Christians came via the tin trading route to Cornwall, and for these hardy travellers it was but a short distance to Ireland. Further evidence of incomers from the Near East may be deduced from a sixth-century carved stone in Scotland called the Drosten Stone, which bears an inscription in Greek.

'What has all this to do with art and craft?' I hear you ask. Actually, a great deal. Once Celtic monastic communities were established in Ireland, one of the most creative periods in the world's history began. By about the sixth century AD Celtic ornamentation in the form of knotwork, complex spirals, key patterns and zoomorphic designs were being carried out, at first on small artefacts and subsequently, in the next two centuries, on a larger scale. Descendants of the Irish monks travelled to western Scotland and on to Lindisfarne, initiating the era of the illuminated Gospels, some of the greatest art treasures ever seen. The Book of Kells is reputed to have been created on Iona in the Inner Hebrides, and the Book of Lindisfarne was designed and illuminated on Holy Island, off the Northumbrian coast. The magnificent, carved high crosses of Ireland and western Scotland, some of the finest stone sculptures to be found anywhere, were also created during this era. The one illustrated opposite is at Monasterboice, County Louth, Ireland, and is of exquisite workmanship. These crosses, which have intricate knotwork around the ring and on the base, are sometimes known as 'scripture crosses' because of their elaborate depiction of biblical scenes. It is dedicated to Abbot Muiredach, who died about AD 992. Even though it has withstood almost one thousand years of Irish weather, this magnificent sculpture is in fine condition.

Amazingly elaborate and beautiful Celtic designs were also lovingly and painstakingly transferred onto silver religious items,

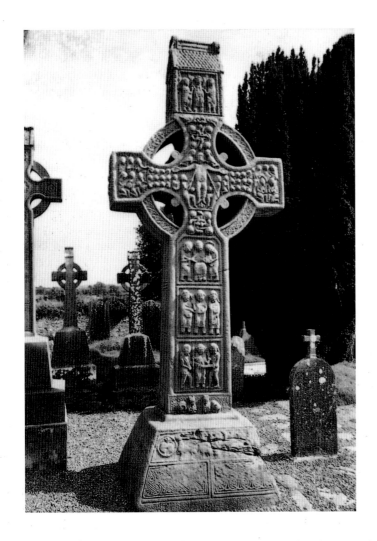

Abbot Muiredach's cross,
Monasterboice, County Louth,
Ireland.

creating such masterpieces as the eighth-century Irish Ardagh and Derrynaflan chalices, ornamented ceremonial crosses such as the Cross of Cong, and reliquaries (small, portable, highly decorated shrines, usually made from precious metals), which contained relics of saints. Many secular items of jewellery and metalwork were also created, such as the familiar penannular brooches, of which the Irish Tara brooch is probably the most intricate and best known example, with its amazingly delicate and intricate gold filigree decoration. No doubt designs were elaborately carved onto many wooden artefacts, both sacred and secular, but few of these have survived.

In the late twelfth century a travelling ecclesiastic called Giraldus Cambrensis (Gerald of Wales; *c.* 1146–*c.* 1220) made a journey around Ireland, keeping a diary as he went. On seeing one of the illuminated Gospels (he doesn't say which one) he wrote:

> *If you take the trouble to look very closely, and penetrate with your eyes to the secrets of the artistry, you will notice such intricacies, so delicate and subtle, so close together and well-knitted, so involved and bound together, and so fresh still in their colourings that you will not hesitate to declare that all these things must have been the work, not of men, but of angels.*

This would seem to be the first actual written testimony of an avid Celtic art and design enthusiast, written in Latin in the late 1100s.

With this enormous explosion of creativity within the early Irish monastic system it is hardly surprising to find that Celtic artwork and its associated crafts spread to other places. Like their European predecessors, the Celtic monks were imbued with a wanderlust, and many travelled by land and sea for vast distances. In his book *The Brendan Voyage*, Tim Severin showed that Irish monks could have crossed the Atlantic and landed in North America. Rather nearer to home were the travels and adventures of Celtic monks and their followers from Ireland, two outstanding examples being St Columban (*c.* 540–615) and St Gall (d. *c.* 640). St Columban travelled for years throughout northern Europe, founding abbeys at Annegray, Luxeuil and Fontaine in France, staying for a while in Switzerland and finally crossing the Alps to found a monastery at Bobbio in Italy. One of his followers, St Gall, remained in Switzerland, where a large monastery with a library of international repute was founded in the century after his death.

As the Celtic monks and their descendants travelled, so too did their skills as artists and craftsmen. Celtic art had once more returned to Europe, albeit in a much modified and more elaborate form than the strikingly bold and beautiful designs of the pre-Christian La Tène era.

The monastic community at Tours, in what is now France, was patronized by Charlemagne. It produced some finely illuminated

manuscripts that show a strong Celtic influence, including the Bible of Charles the Bald, and the St Martin des Champs Gospels, both of which are now in the National Library of Paris. The mid-eighth-century Gospels of Echternach and Maaseik and the Trier Gospels contain fine illuminated pages, decorated in a style that can be directly traced back to the Northumbrian and Irish Celtic manuscripts. Other examples are the Gospels of Cutbercht, now in the National Library, Vienna, the Barberini Gospels, now in the Vatican Library, Rome, and the Montpellier Psalter, now in Montpellier University Library, France. The manuscript known to have travelled the furthest distance is the Leningrad Gospels, a beautiful late eighth-century Northumbrian-Celtic illuminated book, now in the Library of St Petersburg, Russia. It is thought, however, that this manuscript was created in western Europe and was presented as a gift at a later date to a member of the Russian aristocracy.

More than a thousand years ago the Celtic art form was internationally accepted for its supreme beauty and skill. The surviving Gospels and associated religious artefacts in various countries bear witness to this fact.

In the Celtic lands of Ireland, Scotland, Wales, Cornwall, the Isle of Man and Brittany crafts and artwork continued to be produced, much within the monastic communities or in places where itinerant Celtic monks, mostly descendants from the original Irish monasteries, had established hermitages or small centres. In Scotland and Ireland, for example, magnificent disc-headed crosses were being sculpted with extremely complex designs until at least the late fourteenth century. One of the last known to be carved is the striking Priory Cross, on the Isle of Oronsay, off Scotland's west coast. The complexity of the knotwork on this cross has to be seen to be believed.

Following the dissolution of the monasteries in England under Henry VIII, which took place during the early to mid-1500s and also because of the changes that were occurring within the structure of the Church itself after the Reformation, the production of major Celtic works of art and crafts in a religious context declined rapidly. It was, however, impossible to completely destroy this magnificent tradition, and the movement became more closely associated with secular rural communities and villages. Country craftsmen would incorporate some Celtic designs into pieces for everyday use, as well as into jewellery and

items for personal adornment for the wealthy. This crafts movement, which also embraced ancient traditions of musical instrument making and, in Wales, the highly skilled craft of lovespoon carving, continued slowly, quietly and unobtrusively until Victorian times, when Celtic designs began to be recreated. This was most widely evident on stone crosses in churchyards. Their function now, however, was of grave-marker, unlike the original Celtic high crosses, which were used as meeting-places and carved 'to the glory of God' by master craftsmen. Many of these Victorian crosses were poorly executed and lacked the design skills of the early Celts, but there are a few fine examples, which were obviously carved by talented sculptors who had thoroughly researched the subject.

The beginning of the twentieth century saw a revival in Celtic arts and crafts, which has continued to gather pace until the present, when the art form and its application to crafts of various kinds is being practised throughout the world by many dedicated and highly talented people.

The main pioneer of this revival in the early twentieth century was J. Romilly Allen, who travelled widely in Britain and Ireland, researching meticulously into all the examples of Celtic art he was able to locate. In 1904 he published his pioneering book *Celtic Art in Pagan and Christian Times*, which has recently been reprinted. It is illustrated with artefacts, crosses and carvings, which are organized into specific categories that Romilly Allen dates from the Bronze Age to the late Christian period. This was the first work of its kind to be produced, and it is still regarded as a classic, with its fine black and white photographs and its line illustrations.

Romilly Allen's obsession with Celtic art coincided chronologically with that of another great writer and traveller, W.Y. Evans Wentz, who is perhaps better known for his books on eastern mysticism, including *The Tibetan Book of the Dead*. Evans Wentz was deeply interested in the oral traditions of the Celtic peoples relating to 'otherworldly' matters, and he travelled extensively in all the Celtic lands. He lived among the people and wrote down the stories, legends and events that were told to him by the older countrymen and women he met, realizing that if this precious folklore were ignored, most of it would soon be lost for ever. In 1911, seven years after the publication of Romilly Allen's book, Evans Wentz published his fascinating book *The Fairy Faith in*

Celtic Countries, which contained the fruits of his painstaking research. Like Romilly Allen's book, this work has been reprinted relatively recently, and it is a mine of valuable information about the Celtic tradition.

During the 1920s the work of the key figure in the Celtic art revival, George Bain, began to become known. Bain worked as a book illustrator from his late teens, and he took up Celtic art as a means of relaxation from the pressures of work. His hobby developed into a lifetime's dedication to the subject. He visited most of the Celtic and Pictish carvings in Scotland, as well as poring over the Gospels of Kells, Lindisfarne and Durrow and other lesser known early Celtic manuscripts.

Eventually he produced a series of 'how-to-do-it' books for Scottish school children, and this was the first time since the creation of the great Gospels about 1,200 years earlier that someone had accurately and meticulously recreated the geometric methods of the construction of Celtic artwork. Bain's work received much acclaim from many quarters, including overseas, as the fame of his books spread. The books gave a tremendous impetus to the revival of Celtic arts and crafts, and beautiful crafts began to be created both by school children and by older enthusiasts throughout the world.

After Bain's death the books he had produced, along with much new material, were produced as a single volume, *Celtic Art: The Methods of Construction*, which was first published in 1951. Many highly acclaimed Celtic craftworkers received their first lessons in creating designs from this book, and for some it is still a bible, showing as it does how to create entirely new designs in the Celtic tradition from basic principles. Bain's book has influenced the Celtic arts and crafts world more than any other, and in recent years it has led many people throughout the world to experiment with, and obtain great enjoyment from, the art form. It should be noted, however, that there are some highly acclaimed Celtic craftworkers who have developed their own unique designs as a continuance of their own Celtic traditions, independent of Bain's methods.

This book, *Celtic Crafts – The Living Tradition*, presents through text and illustrations some of the best work from talented artists and craftspeople working in various media, including descriptions of the methods they employ and the associations of their work with the living Celtic tradition.

GOLDWORK

I<small>T WOULD SEEM</small> appropriate to begin our journey around the workshops and craft centres of the Celtic world with gold, the metal that Julius Caesar tells us was so prized by the Celts. Examples of early La Tène Celtic goldwork dating from the fifth century BC onwards have been discovered throughout Europe, including Britain. Fine pre-Christian Celtic goldwork is also found in the form of coinage and in the magnificent torques of the second and first centuries BC, superb examples of which were excavated in Norfolk in the 1950s. Several hundred years later, from the sixth to the ninth centuries AD, exquisite jewellery, mainly in the form of religious artefacts, was being produced by Irish monks within the Celtic monastic system, and a number of wonderful examples can be seen in national museums.

In all the Celtic countries there are a few goldsmiths who closely follow their native traditions, but here we focus on Tregaron, in the heart of rural west Wales, where Rhiannon Evans runs the internationally renowned Welsh Gold Centre. Her name-sake in Celtic mythology can be found in the *Mabinogion*, a collection of twelfth-century Welsh tales that recall pre-Christian times when Wales and Ireland were nearer to being one nation. The Rhiannon of legend came from the Otherworld of Annwn (meaning literally 'that without depth') to live among the mortals of Ceredigion, the area now known as Pembrokeshire.

Rhiannon herself is Welsh-born and bred. She attended the University College of North Wales in Bangor, intending to become a vet. This was not to be, however, and in 1971 she married and moved to Tregaron, returning to her earlier interests in arts and crafts and opening a craft shop and gallery, the Craft Design Centre of Wales, which specialized in the best of Welsh and Celtic products. Siezed by a need to find expression for her own fervent interest in the Celtic tradition and to work within an

Rhiannon Evans in her workshop at the Welsh Gold Centre, Tregaron, Dyfed.

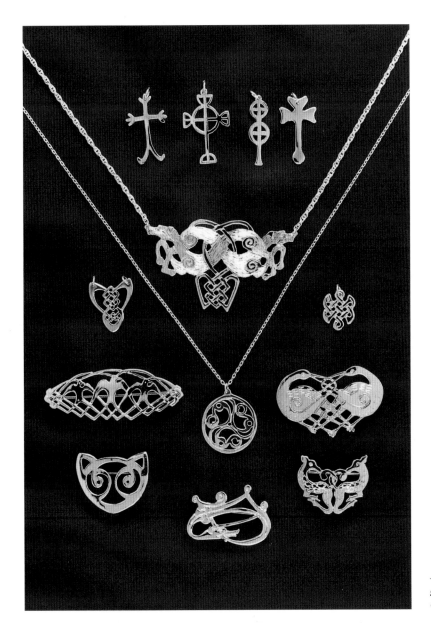

Examples of Rhiannon's fine gold jewellery from the Welsh Gold Centre.

artistic medium that she felt was her 3,000-year-old artistic birthright, Rhiannon began to experiment with precious metals. At first, she produced items only for the craft shop, but her innate talent was recognized when she won the award for design in silver at the National Eisteddfod of Wales in 1976.

These were the humble beginnings, almost a quarter of a century ago, of a business that has been growing ever since. A strong sense of purpose seems to have motivated Rhiannon during those early years in the mid-1970s and early 1980s. Despite a young family and a lack of formal training of any kind, Rhiannon became an accomplished gold- and silversmith, selling her products to Germany and the United States.

The basis for her designs was established after a visit to an exhibition of Celtic craft at the Hayward Gallery in London. It was then that Rhiannon decided that she wanted to design jewellery according to the ancient tradition, and the distinction between her jewellery and that of many other craftworkers is that all her work is original. She says that she designs within and according to the Celtic tradition but that she never copies museum pieces. Ancient Celtic crosses, some of them very plain and simple, carved on standing stones, such as the fine tenth-century great cross in Nevern churchyard, Dyfed, are another source of inspiration, as are birds and animals from within the ancient Celtic era.

In 1980 she bought electrical equipment to help with the work, and began to train the first of her assistants. Meanwhile, she forged trade links with shops in England and Wales so that her work could reach a wider audience and extend the market for her jewellery. By this time the craft centre was open all year round. From 1984 the shop developed an international reputation, and the jewellery sold well in Britain, Europe and the United States.

Rhiannon was one of only three goldsmiths licensed to buy and work Welsh gold from the Gwynfynydd Mines, near Dolgellau. This has been the only gold-mine in Britain to produce gold in commercial quantities for several years, and the combination of scarce gold and unique designs make the Welsh gold items extra special. She was commissioned to make pieces for the Gwynfynydd Gold Company, and before that for the Clogau Gold Company. Unfortunately, the mine at Gwynfynydd changed hands in 1989, and the future of Welsh gold mining is uncertain, but Rhiannon was able to acquire some gold – although the price is 'beyond reason' – and in the immediate future she will be producing a range of pieces using 10 per cent Welsh gold. This material is notoriously brittle, and extreme care has to be taken when it is used for jewellery. She says that when working with Welsh gold: 'I have felt my hand being taken out of the fire. It is a

feeling. I get told what to do.' Rhiannon is pictured in her work-shop on page 20 fashioning an intricate gold ring. The finished product, which is a commission for the Archbishop of Wales, is also illustrated below.

Welsh gold ring inset with a garnet, commissioned for the Archbishop of Wales.

In 1986 Rhiannon was commissioned to make a piece in Welsh gold for a film to be broadcast on S4C, the Welsh-language TV channel, and in 1987 a special jewellery shop, the Welsh Gold Centre, was opened within the craft centre. This contained a workshop where the public could watch the jewellers at work. During this period Rhiannon made many unusual commissions, including a silver cross for Archbishop Desmond Tutu, and a gold morse (or clasp) for the Archbishop of Wales's new robes. She also made the gold medal in memory of Richard Burton that was presented by his widow, Sally, as an Eisteddfod prize.

In 1989–90 the Welsh Gold Centre received a Rural Enterprise Award for exceptional business development, and it also established trade outlets with British Heritage centres, Past Times shops, National Trust shops throughout Britain and CADW (Welsh Historic Monuments) shops throughout Wales.

In spite of the growing international reputation enjoyed by the Centre, there is an unswerving loyalty to the ancient Celtic tradition, and each piece of jewellery is meticulously hand-crafted within this tradition. The illustration shows just a small selection of Rhiannon's exquisite works, many of which reveal the influence of the Irish wolfhounds, which she has kept and bred since the business began.

Given that Rhiannon is a Welsh-speaker born and bred, with roots so deep in Wales that even a short-term absence causes her distress, it is not surprising that stories from the *Mabinogion* feature strongly as the inspiration for much of her work. In addition, extensive travel within Wales to sites of spiritual and religious significance to the Celts has inspired a range of Celtic crosses and other designs, which demonstrate the continuity between the Celtic religion and the early Christian church. The fine tenth-century Celtic cross in Nevern churchyard is one of the major sites in the Ceredigion area.

In 1991 Rhiannon produced a special range to coincide with the Wales Tourist Board's Celtica 1991 celebrations. These pieces were based on actual archaeological finds displayed in the National Museum of Wales in Cardiff. Also in 1991, the work of the Welsh Gold Centre was featured on local TV and radio and in national journals in Germany, Belgium, the United States, Australia, Ireland, England and Japan.

Rhiannon was commissioned to produce a range of commemorative jewellery for the J.R.R. Tolkien Centenary Conference that was held in Oxford in 1992. She was delighted to do this, saying that it was an entirely appropriate commission, as her work is influenced by Celtic legends and traditions, and Tolkien's tales were largely based on the same themes. Reading all Tolkien's books – and enjoying them – made the creation of the jewellery all the more fascinating. Centenary rings, modelled on the Tolkien Society's logo of the dragon, were made in chunky Welsh gold, and the collection as a whole took six months to produce.

In 1992 designs from her range were selected for sale in the British pavilion at Expo '92 in Seville, Spain. Since 1992 major commissions have included making an episcopal ring for the

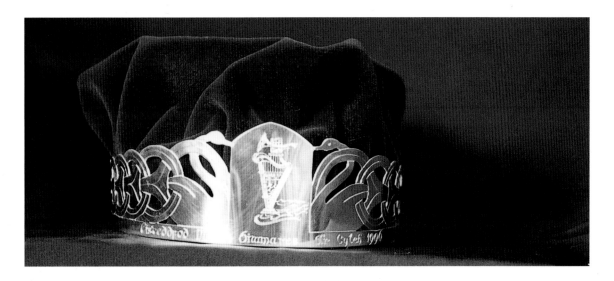

Bishop of Bangor and a silver medal to be awarded for the chief composer at the National Eisteddfod of Wales. In 1994 and 1995 she designed a crown and medals for the University of Wales Eisteddfod, and in 1996 a crown for Eisteddfod Môn, held in Beaumaris on the Isle of Anglesey.

Silver crown commissioned in 1996 for Anglesey's Eisteddfod Môn.

The Welsh Gold Centre recently celebrated its twenty-fifth year in business, and a limited edition range of Celtic jewellery and crafts was made available to the public. The celebrations started on 25 May 1996 and were accompanied by live music from the Welsh folk group, Hergwd.

Rhiannon's ideal, to which she has rigidly adhered, is to participate fully in every aspect of her craftwork. She says that she has never wanted to expand into a large business, and she feels that if her business increases beyond a certain point, she will lose touch. As she says, 'I want to be involved right down the line.'

The Welsh Gold Centre is a thriving business, attracting customers to Tregaron from all parts of the world. It has become a near-mandatory port of call for visiting Welsh exiles and those people with Celtic connections who are seeking their cultural roots. In addition to her two eldest sons, who help her to make the jewellery during their holidays, Rhiannon employs six people on a full-time basis. The company communicates through the medium of the Welsh language, true to the tradition, but speaking and corresponding in English and other languages when appropriate. The Welsh Craft Centre very much embodies the continuity of the living Celtic tradition.

SILVERWORK

HE CELTS' PROWESS in silverwork is well known. During the first millennium BC in Europe and also to a lesser degree in Britain and Ireland, beautifully decorated items of high quality were being made, including torques for wearing around the neck and arm, brooches, small sculptures and silver coinage. Larger items were also made, the best known being decorated silver cauldrons. The finest example of these, which was found at Gundestrup, Denmark, dates from the second or first century BC. The decoration on this magnificent piece is highly detailed and is believed to portray, among other characters, the Celtic deity Cernunnos, holding a serpent and a torque, and Tararnis, the Celtic god of the wheel.

During the Celtic monastic era some of the finest silverwork items ever were produced. These date mainly from the seventh to ninth centuries AD, and they were made predominantly in Ireland, including such masterpieces as the Ardagh and the Derrynaflan chalices, and the fantastically intricate penannular brooches, such as the Tara and Hunterston examples.

Silver neck and wrist torques from Hebridean Jewellery, South Uist, Outer Hebrides.

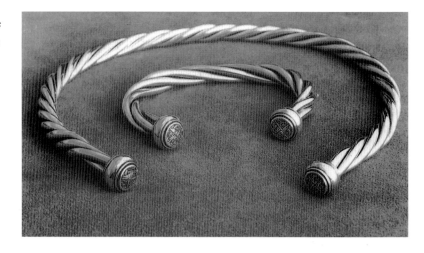

The tradition of the Celtic silversmith has remained alive for the best part of two millennia and today continues to grow. Silver jewellery workshops can be found in all the Celtic countries as well as in mainland Europe and America, some producing fine original work using designs inspired by the early La Tène era, others drawing on the illuminated Gospels of the sixth to eighth centuries, and a few using their own designs, developed from first geometric principles, to ensure originality and uniqueness. In this section we look at the work of two silverwork studios.

Fine silverwork is today being produced and marketed on the island of South Uist in the Outer Hebrides (now known as the

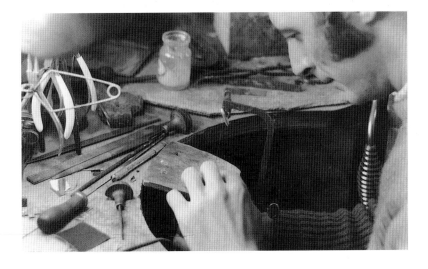

John Hart at work in his studio in South Uist.

Western Isles), off the northwest coast of Scotland. Here, at Iochdar, John Hart runs his own workshop, Hebridean Jewellery.

John left school when he was seventeen and was apprenticed to his father, who had a small jewellery manufacturing business in Glasgow. Most of the designs made by his father were inspired by the ancient work of the Celts, and John remembers that he was a really great craftsman, 'excelling in the skills of piercing and engraving, which he used to great effect in creating his master patterns, from which the master moulds for casting were made'. The company also produced a lot of beautiful 'hand-cut' jewellery, which was sold at ridiculously low prices, the reason, John says, that his father never became even comfortably off financially.

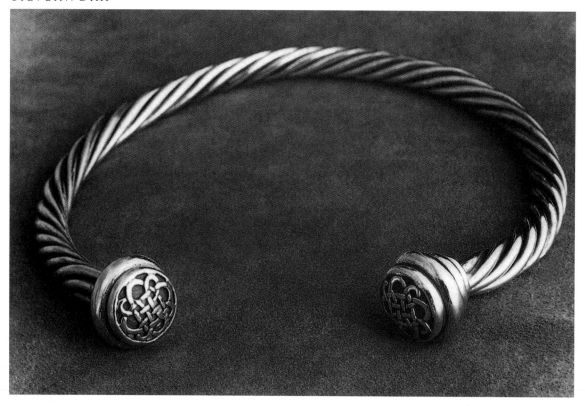

Silver neck torque made by Hebridean Jewellery.

Driven by a lack of decent wages and an obsessional interest in mountaineering, John left the family business to take casual work as a driver, labourer and outdoor pursuits instructor. This gave him plenty of time between jobs to pursue his hobby, which was fine until he became tired of being continually short of funds. As an outside observer he could see where his father had been mismanaging his business, and he felt that he could make a living from making jewellery if he could find premises in a suitable rural setting somewhere on the west coast of Scotland.

His father, who was pleased that John's training was not going to be wasted, helped him out, allowing him to use the facilities in his own workshop while he was getting started with the first pieces in his new range. Because John had no capital, he had to find premises to rent, but suitable premises seemed to be very thin on the ground. However, he had a lucky break when an old widow, known locally as 'Bean Nellie', who lived on a croft on South Uist in the Outer Hebrides and had some outbuildings not in use, responded to one of his advertisements. In September 1974 he went for a look.

John had always been fascinated by the Outer Hebrides, and throughout this chain of islands there are several inspiring Celtic and prehistoric sites, some of them in the most beautiful locations. One such is the stone circle complex at Callanish on the Isle of Lewis, which is probably the finest example of its kind anywhere. The stone circle is extremely spectacular, with its many tall stones arranged in a gigantic 'wheel' cross, but its size means that the pattern is visible only from the air. The site itself is said to be at least 5,000 years old. The illustration below is possibly one of the earliest photographs known of Callanish – it was taken around the year of Queen Victoria's Silver Jubilee (1897). The man in period clothing standing against one of the stones gives a good idea of their size.

A silver Celtic ring made by Hebridean Jewellery.

Callanish stone circle, Isle of Lewis, c. 1897.

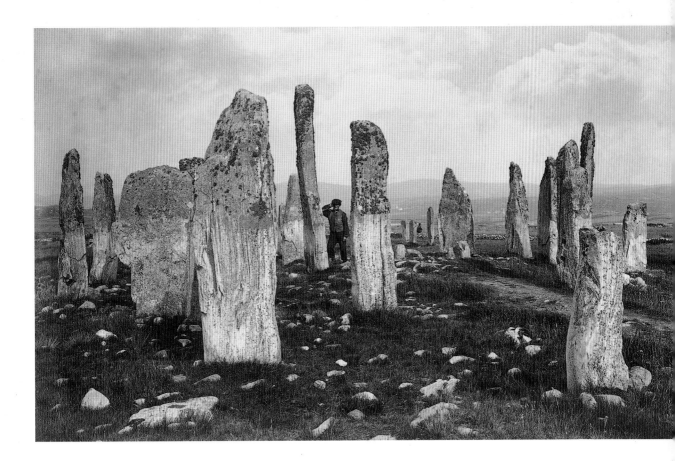

The building that Bean Nellie was offering was an old stone byre with a corrugated iron roof, a dirt floor of about 450 square feet, and no water or electricity – not exactly suitable for what John had in mind but certainly with potential. By this time John was almost despairing of finding anything else, so he decided to offer as much as he could safely afford – £10 a week. Bean Nellie gravely shook her head, saying 'Oh no, no!' John's heart sank. Then she qualified her statement: 'Oh no, I couldn't possibly take all that!' Much to John's relief they agreed to a rent of £10 a month. Conditions were difficult at first – some friends helped to put in windows and a floor – but in a few months John had established a little workshop where he took on apprentices and even managed to have a retail outlet. During this time he was deriving inspiration for his jewellery from various sources, including a travelling exhibition of ancient Celtic jewellery, the Work of Angels. (A fine illustrated book based on this exhibition was subsequently published and is a

Celtic silver ring, made by Hebridean Jewellery.

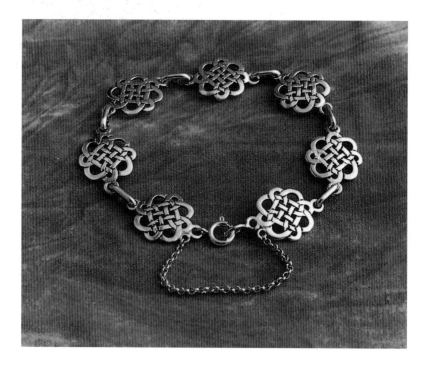

A Celtic silver necklace, featuring knotwork design, from the workshop of Hebridean Jewellery in South Uist.

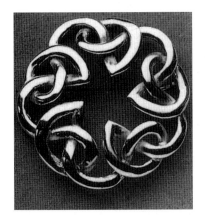

Three examples of fine silver brooches, inspired by Celtic design, from Hebridean Jewellery. Elaborate interlacing and zoomorphic art are typical of Celtic silverwork.

delight for any enthusiast of Celtic jewellery.) John was very much taken by the large, ornate pieces on display at this event, and although big, heavy pieces of jewellery are necessarily expensive, he felt that they could be attractive enough to sell if they were made to a sufficiently high standard. At the time there was nothing like this available from contemporary jewellers, and he hoped that they would attract attention to the workshop's output.

Until 1981 John and his wife lived in a caravan, but they managed to have a house and workshop built with financial help from the Highlands and Islands Development Board, the house being built on a site from Bean Nellie's croft, close to the old workshop. John's father had retired in 1979, and all his designs became available, allowing John to increase his range significantly. Late in 1993 he acquired a shop in Fort William on the Scottish mainland, and this has become a successful venture. In both shops – on South Uist and at Fort William – John promotes Celtic culture, not just through his own jewellery but through the work of other jewellers and through crafts, books and music. John also sells his work through mail order, and his catalogue has brought in enquiries and orders from many parts of the world.

The second silverwork studio, Hrossey Silver, is run by Jane and Pete Rowland on the remote Orkney Isles off the north coast of Scotland. Jane and Pete are people who set their hearts on a particular lifestyle in a remote location and who, through much patience, perseverance and hard work, are becoming successful in their craftwork as well as rebuilding their house and workshop in traditional Orkney stone.

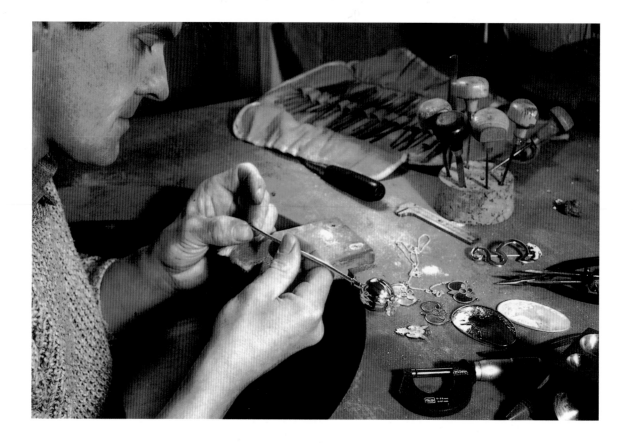

Pete Rowland at work in his silverwork studio, Hrossey Silver, on the Orkney Isles off the north coast of Scotland.

According to Jane it all started in 1991, when they were back-packing around the Scottish Highlands and Islands and arrived on Orkney quite by chance. They immediately fell in love with the islands. Like so many other people it had always been their dream to work for themselves, and they found Orkney, which is a self-contained community, more suitable for running a business than the Highlands. They returned home and put their house on

the market. They began to gather any information about Orkney they could find, including what types of craftwork were already being produced there, because the last thing they wanted was to produce work similar to what was already being made on the island. They had their name added to the property mailing list and even had the Orkney local paper delivered, but the slump in the property market made it impossible for them to sell their house. Pete then decided that it would be best if he went back to college to improve his silversmithing skills.

A couple of years later they saw an advertisement in *The Orcadian*, the Orkney local paper, offering work at a pottery. Jane had trained to be a potter, and she decided to apply. She had to travel 540 miles for the interview, but she was offered the job.

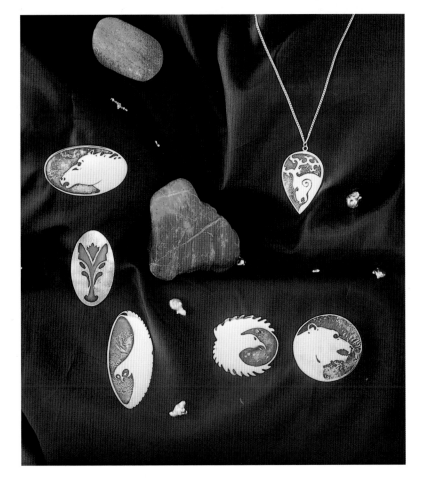

Silver brooches and a pendant made at the Hrossey Silver studio. The pendant features a stag's head and the brooches show other Celtic 'power animals': a horse, eagles and a bear.

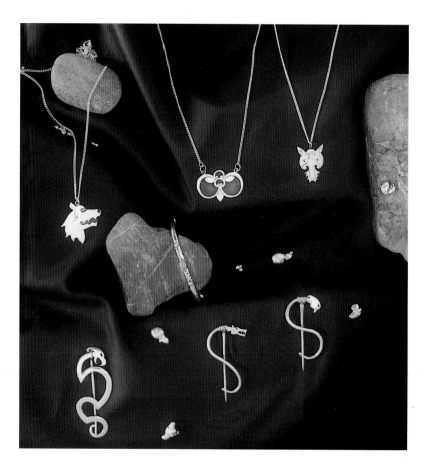

Stylized dragon brooches and pendants in silver, made by Hrossey Silver.

Almost as soon as she got back home, they sold their house. Having thought about moving to Orkney for so long, they had planned exactly what they were going to do. They wanted to buy somewhere cheaply, so that they could put as much money as possible into the business. While they lived in the building, they would, they hoped, renovate it, including some outbuildings for the workshop and a couple of acres for the horse.

In reality, things proved rather different. They ended up in rented accommodation, and over the next ten months this swallowed up money they hadn't anticipated spending. However, they did end up with a 50-acre croft, a completely derelict house in which cows had been living for the last thirty years, with a stunning view. They had to live in a caravan, and spent what Jane describes as 'a really interesting winter in the caravan, especially around the equinoxes in September and March, which is when the

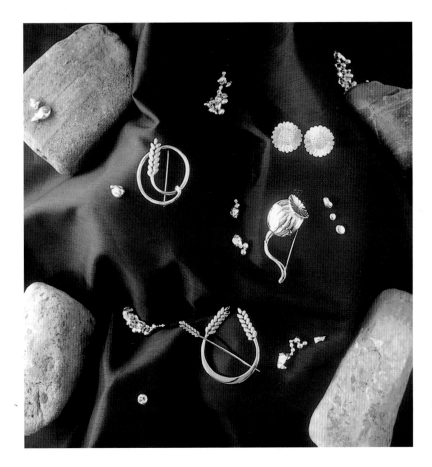

Brooches and ear studs, which have been created from the inspiration of nature – these examples feature wheatsheafs, a poppy head and sunflowers.

gales really started'. The highest wind speed ever recorded in Orkney is around 125 miles per hour, and Jane recalls their first Christmas on the island: 'We were in the thick of 80 mph blizzards, which really battered the caravan, and the electrical power was going off all around us. Some friends came to rescue us in their four-wheel-drive motor, and invited us to stay for a short while in their nice solid house. So we ended up having Christmas by candlelight, with a large roaring fire and plenty to eat and drink. This was the best Christmas we had had in a long time. When we returned to the caravan it was so cold that the water pipes under it had frozen and didn't thaw out for three weeks. We had to melt snow for our water during that time.'

Soon after this Pete was lucky enough to be offered bench space in another silversmith's workshop, and now they had started the business, Hrossey Silver. 'Hrossey', which means 'Horse

Island', is the ancient Norse name for the Orkney mainland. By this time they were rebuilding the house and had also started building the workshop from scratch using traditional Orkney stone. Jane had enrolled at evening classes for woodwork so that she could help to make the windows for the workshop and the show-cases for their first silverwork display at the Highland Trade Fair in Aviemore. The Orkney stand is run by Orkney council, and new businesses are offered two years' free display on the stand. The quality of Orkney craftsmanship is highly prized among customers.

Since then things have improved in all respects. In 1996 a new venture entitled the Craft Trail was started on Orkney. A colour brochure is available, giving short profiles of different craft-workers and pictures of their products. Tourists to Orkney can plan their route around the workshops they would like to visit, and this has proved a popular and successful project.

The inspiration for the Rowlands' work comes mainly from the Stone Age period, the early European Celts and the wonderful flora and fauna found on their doorstep. Orkney is rich in archaeological wonders, the most famous being the Bronze Age stone circle of Brodgar and the Stones of Stenness. There is also the fine Maes Howe chambered cairn, which is about 5,000 years old and whose entrance passage is aligned with the sun at the winter solstice, and Skara Brae Neolithic settlement, which dates from about 3000 BC. It is said that if you own a piece of land anywhere on the island, sooner or later you will dig up something of historic interest.

Jane and Pete are constantly improving their range of designs. For example, if they locate better-quality findings for their jewellery they will use them even if they are more expensive. The few silver castings that they produce are not just polished, but are hammered and textured to improve the finish and to strengthen the metal. The silverware is mainly hand-made, ranging from life-size poppy and thistle scent bottles to decorated buttons and belt buckles. They have also recently extended their range to create items from gold.

Jane feels that the range has evolved in a natural organic way. For example, a customer will ask for a poppy brooch, and almost as soon as the prototype has been sketched, the piece has become part of the established range. They carry out a lot of market research before producing a specific item to make sure that

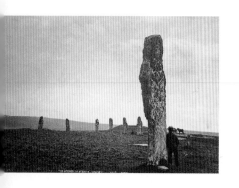

The Ring of Brodgar stone circle in the Orkney Isles. This photograph was taken c. 1897; a horse and trap can be seen in the background.

nothing like it is already being produced. Another aspect of the work that they find satisfying is the creation and exhibition of one-off pieces. Pete likes to work with different metalworking techniques, and he has long admired Japanese artefacts. Among the techniques he uses are repoussé, mokumi, recticulation and granulation, which allow them to create items in different media, such as wood, bone, vegetable-ivory and stone. In addition to commissions for silverwork, they sometimes receive requests for more unusual pieces, and so far these have included items as diverse as a coconut cup and a silver-mounted bronze dagger for a druid.

At present they have four outlets on the Orkney Isles, and also sell to outlets throughout Britain. They have recently completed their first orders for Japan and the United States.

The ancient Stones of Stenness, Orkney Isles. This photograph was also taken c. 1897. The man standing in the foreground gives an idea of scale.

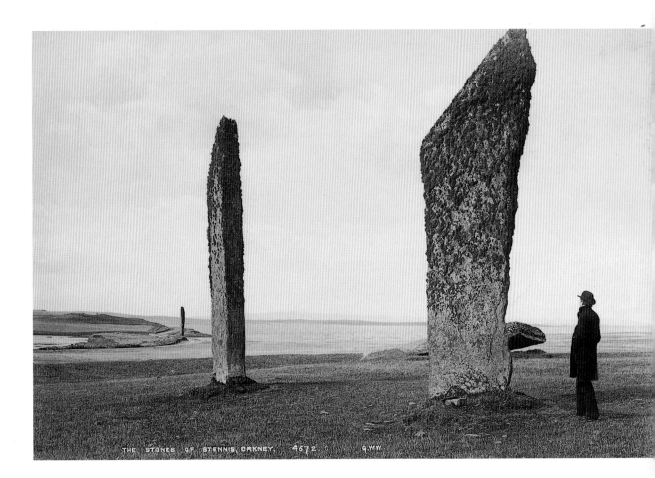

PEWTERWORK

Jeni Cockram at work in the Piran Pewter Company at Padstow in Cornwall.

THE WORKSHOP OF Piran Pewter Company in Padstow, Cornwall, is run by Jeni, and Jerry Cockram. Jerry is Cornish-born, and both he and Jeni are dedicated to the Celtic environment in which they live.

According to Jeni, cultural exchange between the Celtic peoples is not a twentieth-century phenomenon. Although Roman rule never reached Scotland or Ireland, it filtered into Wales and Cornwall, leaving largely undisturbed the most westerly extremes of the mainland during the three hundred years' occupation. In effect, Wales and Cornwall remained a fairly quarrelsome nation with a common Brythonic language, which survived despite the westerly movement of Saxon influences during the following centuries. It was not until the Severn valley fell into English hands that Wales and Dumnonia (Cornwall, Devon and Somerset) began to diverge as two separate nations. Cornwall became culturally isolated from its Celtic neighbours, losing its traditional name Kernow ('horn-shaped land'), and being renamed Cornuwealas or Cornwall, from the early English for 'land of the Cornish foreigners'.

Of all the areas that still claim Celtic roots, Cornwall is perhaps the most anglicized, having lost the struggle for separate nationhood in the tenth century. As the Saxons had marched inexorably westwards in the years following the Roman withdrawal, many Britons from Dumnonia escaped to Armorica, giving it the name Brittany and ensuring a common language, despite the geographical gulf.

Those who remained under an English administration were not a pragmatic people, and spoken Cornish was not extinguished for another 900 years; The independent spirit is still obvious, and there is a reluctance to relinquish old ways and traditions, even when the meanings have been all but lost. Even though Britons were nominally Christians under Roman rule, Christian beliefs

did not fully oust Celtic traditions, which have never quite been lost. The celebration of the Celtic festival of Beltane, although now renamed May Day, has never died out in Padstow, where summer is ritually welcomed by the dancing of the 'Obby 'Oss and its Teazer, a possible survival of the worship of Epona, the Celtic horse-goddess.

Padstow is a small port on the north Cornwall coast, just inside the shelter of the Camel estuary. It was mainly to Padstow that saints and holy men came from Wales and Ireland on their proselytizing journeys to fellow Celts in Cornwall and beyond. Treacherous currents around Land's End meant that it was safer to cross Cornwall by land than to try to circumnavigate it on their pilgrimages to Brittany and northern Spain. Stones in the area inscribed with ogham characters as well as Roman inscriptions testify to the early influences of Irish immigrations, although we can be certain only about the Welsh holy men who followed the route down the 'spine' of Cornwall, from Padstow on the north coast to Fowey on the south coast.

It was not until the 1970s that the old byways, place-names, paths and the stone monuments were painstakingly linked and the Saint's Way (Forth an Syns) was re-opened as a recognized footpath, taking in prehistoric hilltop forts, wooded valleys and sheltered

Ancient Cornish pewter crosses by Piran Pewter Company.

A Cornish sunset photographed close to the workshop in Padstow.

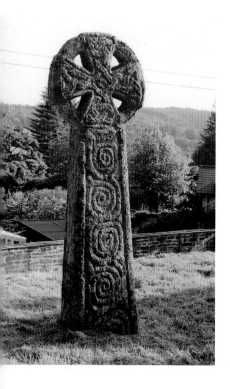

Tenth-century Celtic cross at Cardinham, Cornwall. This inspired the miniature pewter cross on the right, made by the Piran Pewter Company.

hamlets on its route south to Fowey.

The early saints seem mostly to have been the children of Welsh kings who, having eschewed their worldly inheritances, set out on a life of holy self-denial, although much of the evidence to support this has been gleaned from 'lives' written during the Middle Ages, whose writers may have claimed aristocratic backgrounds for their saints to add to their interest.

Cornwall has never been a wealthy county. Tin, other metals and china clay extracted there have, on the whole, been traded and worked elsewhere. No great hoards of jewellery or artefacts have been found in burials, and the tangible evidence of the past comes mainly in the form of hillforts and stones. The history of tin production in Cornwall goes back to before the earliest recorded times, and pewter is 95 per cent tin. A traditional ingredient of pewter was lead, which accounted for the remaining 5 per cent, but for safety reasons lead is no longer used. Pure tin is not particularly pleasing to the eye, and modern pewter contains a small proportion of copper and antimony, which hardens it and makes it easier to work. Both minerals have been mined in the Padstow area in the past. Pewter has a relatively low melting point and takes on a beautiful shine when it is polished; it does not tarnish and takes little maintenance to preserve its sparkle, which is offset by a patina, creating the effect of age and antiquity.

The Piran Pewter Company evolved in the early 1990s as a natural progression from two existing Padstow businesses. Jerry was working as an ornamental blacksmith with a love of traditional designs, while Jeni was a traditional signwriter. Jeni's interest in lettering and illuminated manuscripts led eventually to the design of Celtic-style jewellery. With Jerry's knowledge and experience of metalworking and Jeni's training in design, a co-operative venture making jewellery seemed the obvious choice.

They named their company after Saint Piran (also known as Pirran or Perran), who is said to have sailed across the Irish Sea to Cornwall on a millstone. He discovered the tin-smelting process by accident when he lit his first fire over stones containing tin ore. This sixth-century abbot has since become the national saint of Cornwall and the patron saint of tinners – the Cornish flag, a

white cross on a black background, represents the silvery-white metal against the contrasting blackened ore. St Piran's feast day, 5 March, is celebrated throughout Cornwall. Like St Petroc, his name lives on throughout the county in Perranwell, Perranzabuloe, Perranporth and Perranarworthal, and in Brittany, where Saint-Perran is located south of Saint-Brieuc.

Piran Pewter's first designs were greatly inspired by traditional works, such as the birds from the Book of Kells, the horses from the Inverurie Stone and a selection of designs taken from local stones and crosses, such as the Cardinham Cross and the Lanivet coped stone. Padstow also has an unusual sixth-century stone cross, which was unearthed in Victorian times in the grounds of the local manor house, Prideaux Place, once annexed to the monks of Bodmin Abbey. The head of the Prideaux Cross has been stylized so that the 'wheel' has become almost octagonal. Parts of the shaft are inscribed with interlacing knotwork, another section having been discovered by Andrew Langdon.

As well as old crosses and manuscripts, the wild coastline of north Cornwall is also a great source of inspiration. Jerry gets all his best ideas while running or walking on the cliffs, whether he is thinking about a new design or trying to solve a technical problem with the machinery that he has designed and made for the business and is constantly improving.

From its initial introduction into local craft shops and at craft fairs, the jewellery proved to be popular. Demand was so great that before long the earlier businesses had to give way, and all efforts have been concentrated on the Piran Pewter Company. The range of jewellery and miniature Celtic crosses is continuing to expand and can be found in gift shops across the country, with orders also going out to Australia, Hong Kong and recently to the United States.

It seems that in a fast-moving world where there is so much commercialism and greed, Jerry and Jeni are searching for some meaning in their lives, and this search has led to curiosity about other cultures where some spiritual and perhaps mystical significance is apparent. Nowadays, says Jeni, there seems to be a lasting interest in Celtic design, as its influences weave their way in and out of their lives, just as the knotwork weaves itself through the original designs handed down over the ages. It is the ethos of continuity between this world and the Otherworld that will never cease to inspire the richness of thought and design that typifies the Celtic culture.

Above: Examples of jewellery from Piran Pewter.

Below: Miniature pewter cross inspired by the ancient cross at Lanherne.

41

ENAMELWORK

Christine Forsythe.

HE TRADITION OF enamelwork in Celtic art can be traced back at least 2,500 years. In Europe, during the latter half of the first millennium BC, the Celtic craftsworkers of the La Tène civilization were producing beautiful enamelled artefacts. Most of these were made from bronze, and they range from decorations for horse harnesses to embellishments for chariots, brooches and a few small bronze figurines. During the second and first centuries BC the craft of enamelling spread to Britain, and some extremely fine enamelled bronze horse decorations have been discovered, embellished with just red or with a combination of red and yellow enamels. Notable examples, both dating from the first century BC, are from Santon, Norfolk, and the Polden Hills, Somerset.

The craft of enamelling continued to be practised during the monastic era, which began in Ireland in the fourth century AD and continued until the sixteenth century. Between the seventh and ninth centuries enamelling was also used in conjunction with superb silverwork. The art of cloisonné enamelling, which entails laying the enamel within shapes created by thin wire, which separates the colours after firing, was perfected during these times.

Among the people producing beautiful enamelwork items in the Celtic tradition today is Christine Forsythe, whose enamelwork studio is in Aberdeen. Like many craftworkers, she eventually decided that the creativity and enjoyment to be derived from her craft far exceeded the stress and tediousness of a conventional job. She also found that enjoying being a self-employed craftsworker, albeit on a somewhat reduced wage, was far more productive than holding down a routine job that lacked inspiration and satisfaction.

After leaving university, Christine spent three years working in a tax office, just long enough to make her realize that she never wanted to enter an office again. She then taught English for ten years in various schools around Aberdeen. However, she had

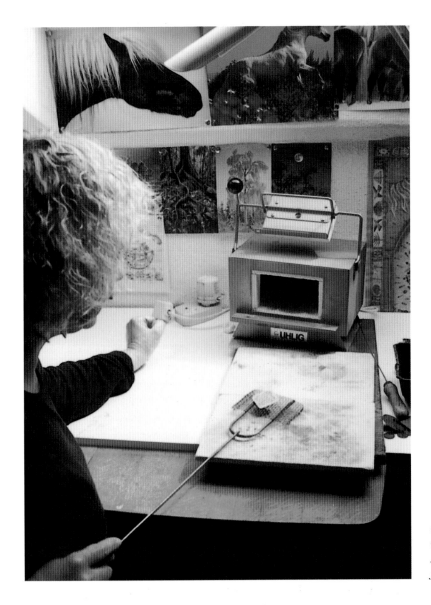

Christine Forsythe at work in her enamelling studio in Aberdeen. She is removing a fired piece from the kiln.

always been interested in the arts, and initially she found painting and drawing the most appealing. Over time, children and other domestic commitments led her to abandon these in favour of more practical ways of finding self-expression, and she became interested in different arts and crafts, including fabric design and printing, screen printing, dress-making, designing and knitting sweaters, embroidery and even sculpture.

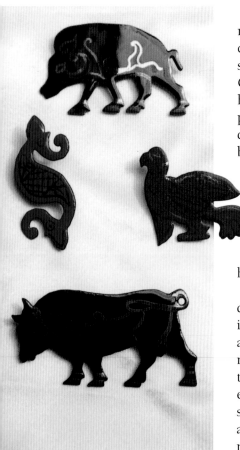

Enamel brooches based on ancient designs, including the Pictish bull carving from Burghead, and a boar from Meigle in Perthshire.

It was not until about 1980 that she first began to design and make jewellery. This started in a modest way and quite by accident, when Christine and her daughter were watching a television programme that featured copper enamelling as a hobby craft. Christine remembered that she had an enamelling kiln, which she had bought in the late 1960s when enamelling enjoyed a brief period of popularity, hidden away somewhere. She and her daughter spent a few evenings having fun with the kiln, making brooches and earrings, without any thought to making any more of the pastime. However, people began to ask where she had bought the jewellery, and when they heard that she had made it, they asked if she would do some for them. At the time she had started teaching and had no thought of changing direction. However, she did continue enamelling, making a little extra money, which was, she says, a new experience, as no one had ever wanted to buy anything she had made before.

Christine finds enamelling a very satisfying craft. It is relatively quick to produce a finished piece, because the basic process involves applying enamel, which is simply a type of glass available in an enormous range of colours, to metal. The enamel is normally used in powdered form, and the piece is fired in a kiln at temperatures between 750 and 900 degrees centigrade so that the enamel melts and fuses permanently to the metal. The kilns are small and compact, so you do not need vast amounts of space, and it takes only one to three minutes for each firing, so the results are quickly obtained, although each piece requires at least two firings. For Christine, part of the fascination lies in combining enamels of different colours and types to produce interesting effects. As she says: 'I also love experimenting with colour, and the craft of enamelwork gives me plenty of opportunity to do that.'

Christine particularly enjoys working with metal, and experimenting with copper and enamel in various ways is endlessly interesting and challenging. This has led her to use other metals, particularly silver. Because she had no training in metalworking, she relied on a mixture of reference books and experimentation whenever she needed to learn a new skill, and this is the approach she adopts even now that the jewellery has become much more than just a hobby. It may appear unconventional, but it suits her – it tends to be her method of learning most things. She has found that she has discovered or developed ways of working that are totally at odds with what would normally be

recommended by more conventional craftworkers but that are, nevertheless, as effective and very often easier than doing it 'by the book'.

She continued to work in this way for several years, resisting the advice of friends who urged her to give up teaching and pursue jewellery full time. She felt that what she did was not good enough and that although friends might want to buy her work, no one else would. However, as she spent more and more time making jewellery and teaching became increasingly less satisfying, she began to investigate the market through various craft fairs throughout Scotland and realized that she could make a crafts business work.

In late 1989 Christine left teaching and set up as a full-time jeweller. This was perhaps not the best time to choose, as the country was soon plunged into recession, but she survived, and now she can wholeheartedly say that this was one of the best decisions she ever made. There have been difficult times financially, but she enjoys being her own boss, making her own rules and having the freedom that self-employment can bring.

A knotwork enamel brooch.

Over the years her work has changed and developed. She increasingly works with silver, and is now also using semi-precious stones and, recently, gold, too. However, enamelling, which started it all off, still occupies about half her time. Although at first she experimented with enamelling on silver, she did not find this particularly congenial, preferring to add colour to silver pieces in the form of stones rather than enamel. She has, however, continued to enamel on copper and has developed a number of ways of producing relatively simple designs that can be sold at reasonable prices and that seem to appeal to a wide range of people.

Christine became interested in using Celtic designs in the early 1990s, although she encountered Celtic art at university in the early 1970s, when she was studying Old English philology and came across a full-colour facsimile of the Lindisfarne Gospels. The intricacy and wonderful, glowing colours of the illustrations

were completely unexpected and quite overwhelming, and she returned to them again and again, ostensibly to examine the linguistic aspects of the writing but finding herself immersed in the graphics. At the time she had no desire to attempt any of the incredibly complex interlacing patterns, but she read widely about the period and the methods used by the scribes.

The other deeply rooted influence in her work is her more immediate environment. The northeast of Scotland abounds with early Celtic and Pictish carvings, and she has incorporated some, such as the ancient Pictish carvings of the bull from Burghead and the boar from Meigle in Perthshire, into her range of designs. Stone circles and the carved stones, such as the famous Maiden

The 'Iona Range' of knotwork enamel earrings, made by Christine Forsythe.

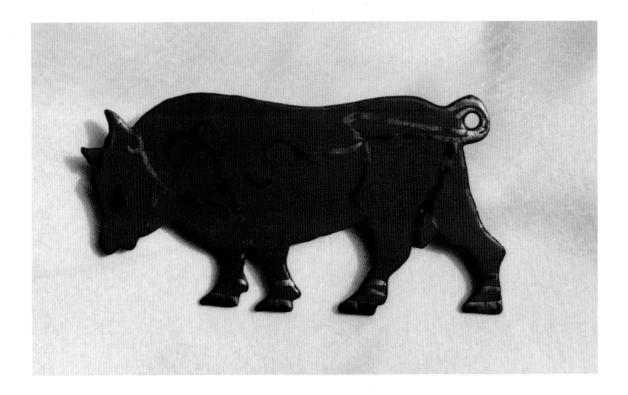

Stone, which lies in the shadow of Bennachie, a local hill with an Iron Age vitrified fort on its summit, were part of the country in which she grew up, and these, too, have found their way into her designs.

When she first started experimenting with Celtic designs, she laboriously painted each one before firing the enamel. This, however, proved to be too time consuming and had such a high failure rate that it proved not to be a viable method. Now she uses a simpler method – she cuts a stencil of the design so that she can produce pieces more quickly and have more time and energy to play with colour combinations, one of the aspects of enamelling that she finds most satisfying.

As well as the familiar interlace patterns, she has used some of the fanciful animals from ancient manuscripts in her work. Many of the same Celtic motifs appear in her silver pieces, and here she is starting to move away from the rigidity of the familiar interlace to produce pieces that incorporate that theme in a more flowing, less structured way. These ideas will no doubt find their way into her enamel work in the near future.

The Burghead bull brooch, adapted from a seventh-century Pictish design; red enamel with gold lustre decoration on copper.

GENERAL SCULPTURE

CULPTURE HAS BEEN at the heart of the Celtic tradition since its earliest recorded beginnings. The diversity of media used and the variety of fine objects sculpted are enormous. From the La Tène era wonderful cast bronze animals, such as wild boars, bulls and horses, have survived, but even earlier sculptures in clay and also in bronze of the chariot, that favourite invention of the Celts, have been found. These sculptures were associated with elaborate burial rites, and figurines and statues of gods and goddesses also feature strongly during this period. In the early Celtic Christian era some of the finest examples of sculpture are the stone carvings, including the unique double-sided figures on Boa Island, County Fermanagh, Northern Ireland, and the intricate and elaborate carving of the great high crosses of Ireland from the eighth century onwards.

Simant Bostock's sculpture and art business, which is called, appropriately, Spirit of the Ancestors, is based in Glastonbury, Somerset. The Celtic and Arthurian legends associated with this region are numerous, and places of pilgrimage such as Glastonbury Tor and the Chalice Well are known to many.

Simant's career as an artist began when he drew blackbirds for his grandmother when he was four years old. 'These early "masterpieces" won me a great deal of attention and praise,' he says. 'My talent had been discovered and my destiny was clear. Only later was it to become obscured and sometimes even forgotten. My grandmother was for me the wisest member of the family. Her country wisdom guided her through ninety years of life with love and enthusiasm. For me she was a good witch and she taught me to see the spirits of the woods and the magic of nature. She told me the names of the flowers and I made pictures

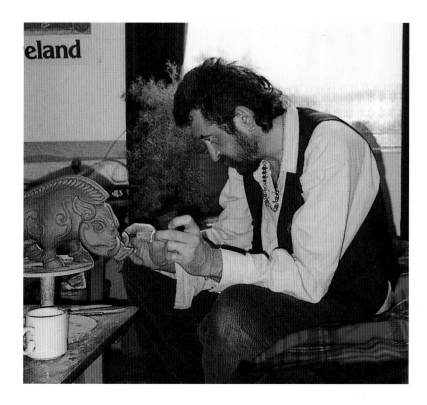

Simant Bostock in his studio sculpting a wild boar in clay.

for her. At school art became my survival kit. It was one of the few experiences of freedom and colour in the imprisoning grey world of the classroom.'

Growing up on the outskirts of Oxford, Simant discovered two places that held an endless fascination and were to provide a continual source of inspiration. One was the Pitt Rivers Museum, an ethnographic collection unparalleled in its diversity and arrangement. Shrunken heads, mummies, voodoo dolls, totem poles, musical instruments, boats, skulls, costumes and feathers are among the objects crammed into a labyrinth of display cases to give the feel of a kind of Victorian junk shop. The other place was Uffington White Horse on the Berkshire Downs. Here, for the first time, he felt the spirit of our ancestors and the power of their sacred sites. Overlooking the panorama of the Vale of the White Horse, the spirit of the ancient Celts, Vikings and Saxons transported Simant's imagination back to a world that felt strangely familiar and in many ways more attractive than the one he had been born into.

After various unsatisfying jobs and hitch-hiking around Europe and the Middle East, Simant went to university to study Fine Art and Art History, but he soon lost interest in the university art department and its preference for abstract painting and began to spend a lot of time working in a local hospital, helping to look after autistic children. He became increasingly interested in their 'world' and eventually decided that psychotherapy and art were the two things with which he wanted to become involved. Simant graduated in Fine Art, and after studying art therapy, he moved to the West Country to work in a mental hospital.

Ten years later he and his family moved to Glastonbury to make a new life. Somewhere amid the New Age circus and all its sideshows, and the myths and legends of the Isle of Avalon, he began to feel that he should start using what talent life had given him. 'I saw myself as an image maker,' he says. 'And this view of myself seemed to come closer to the core of me than anything else. I decided I wanted to try and make a living from the images I made.'

Simant had been involved with Eastern spiritual paths for a long time, but he gradually became more interested in the spiritual heritage of the West. The ancient sacred sites of the British Isles and Ireland and prehistoric art provided a wealth of images and inspiration, and he made copies of Ice Age figurines, Celtic crosses and totem animals of the Celts. Eventually, a small business began to grow.

Because he likes the idea of making things that the average person can afford, he makes clay originals, takes moulds from them and reproduces them in hard casting plaster, which he hand-paints in various finishes. He also enjoys using various materials, and in some of the more original pieces, like the large mixed-media pictures, he uses feathers, bone, shells and other

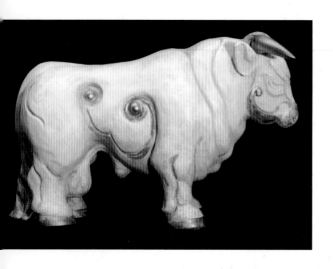

A Celtic bull, sculpted by Simant Bostock in 1992.

items, together with painting and modelling. He is a keen photographer and has amassed a sizeable collection of photographs of Celtic and ancient sites, especially those of the Megalithic era, from the Orkney Isles to Brittany, and from the west coast of Ireland to Drenthe in northeast Holland.

Simant feels a strong connection with both Celtic art and Celtic music, but he has an especial rapport with the landscape of the Celtic countries. He feels that: 'Ideally, I would like to be part of a

community of artists and craftspeople living somewhere in the West Country or Ireland. The power of nature hasn't been completely tamed as it has in so much of England, and the myths and legends of the Celtic people are still alive somehow, especially in Ireland. They are still part of the culture and the land itself.'

His interest in art and creating images has to some extent always been in their magical power, as a vehicle for spiritual wisdom, transformation and healing. Making goddesses has given him a lot of satisfaction, but he now finds that reproducing work can be a bit uninspiring, and if he is not careful all his time can be spent on the production line, with no time to create new work. He would like to make some larger figurative sculptures, inspired by the spirit of our ancestors and their mythology but also having a relevance to the present. Simant finds the Irish legends of the Tuatha dé Dannan especially powerful.

Making copies of the Ice Age Venus figurines and later Celtic gods, totem animals and Celtic crosses was, Simant thinks, a bit like serving an apprenticeship. He felt a strong connection with the artists who had made the originals, some as many as 22,000 years ago, and also came to appreciate their craftsmanship and sense of design. At about the same time he began to make some more original works in the form of large reliefs in mixed media. *The Bog Man* was the first major piece he created after retiring from art therapy. The inspiration was the Tollund Man, who was found in a peat bog in Denmark and dates from *c*.200 BC. The serenity of this man's face, perfectly preserved for over 2,000 years, had always fascinated Simant, who aimed to bring him back to life and cast him in the role of mediator or messenger between our time and the Neolithic era. Simant used plaster, clay, bone, shell and leather to create a picture in which he sat in a stone chamber engraved with spirals and zigzags. These were loosely based on the engravings of Newgrange Neolithic temple in the Boyne Valley, County Meath, Ireland, which he had visited several times. Another piece of work related to Newgrange and the Boyne Valley is *Celtic River Goddess*, a sculpture that was inspired by Boana, the ancient Irish goddess of the River Boyne and consort to Dagda, whose palace was Newgrange.

These chambered cairns, of which Newgrange is the largest, are over 5,000 years old and seem concentrated in a northwest to

The river goddess Boana by Simant Bostock.

51

Simant Bostock's sculpture of The Bog Man, *inspired by the Tolland Man found in a peat bog in Denmark and dating from c. 200 BC.*

southeast spread from Sligo to the Boyne valley. Their associations with the Tuatha dé Danaan, with the light of the sun and, perhaps, the moon and stars, and with spiritual rebirth combine to create an image of a lost Atlantean civilization, whose spectacular achievements are only now beginning to be fully appreciated. With *The Bog Man* Simant wanted somehow to honour the spirit of these people. When he creates a sculpture, especially in mixed media, he feels he is not only making an image, but also a kind of magic. All the materials he uses have, he says, 'a spiritual power. These combine to create a magic spell for healing, or a prayer in visual form. It seems for me it is still a kind of art therapy.'

Living in Glastonbury provides a rich source of inspiration. The myths and legends associated with this area, together with the beauty of the landscape, were what first attracted him to the place. Glastonbury Tor, the legendary home of Gwyn ap Nudd, the Celtic Lord of the Otherworld and King of the Fairies rises on the Isle of Avalon from the surrounding marshland and peat moors of the Somerset Levels. There are the stories of Gwyn ap Nudd riding out on the wind to collect the souls of the dead and bring them to Avalon, the Celtic Otherworld, to await rebirth; Arthur, the Once and Future King, being brought to the Isle of Avalon mortally wounded after the last battle, to be healed; the Chalice Well and the stories of the Holy Grail hidden beneath its spring. One of the things he finds fascinating is the way in which stories like these become attached to certain parts of the landscape and are, perhaps, somehow expressions of the land itself, just as the ancient Celts, like other tribal cultures, acknowledged and respected the spiritual energy of rivers, trees, stones, mountains and lakes.

Christian legends of Joseph of Arimathea coming to Glastonbury after the Crucifixion to establish the first Christian church in Britain, which later grew into one of the greatest medieval abbeys in the country, also show this recognition of Glastonbury as part of a sacred landscape and an ancient centre of

healing, but all this is often obscured by the crowds of tourists and pilgrims who throng through Glastonbury and by the commercialization of the town. Glastonbury has been called 'the Maker of Myths', and it seems always able to stimulate the imagination. Simant finds that when he has been out photographing the Tor at sunrise, the mythological and spiritual aspect of the landscape is at its strongest. 'A lake of mist often surrounds the "island" at dawn, hanging over the Levels and taking one to the threshold of another reality,' he says.

In his work Simant tries somehow to make images that honour the spirit and beauty of the landscape, be it Glastonbury Tor, a stone circle on the Outer Hebrides, or a chambered cairn on the west coast of Ireland. He finds that he is continually learning about the people who built their temples and shrines in these places and endowed them with the stories of their gods and heroes. He has, he says never felt convinced that this ancient world is completely lost forever and feels strongly that the monuments and engravings of the Neolithic peoples and the rich culture of the ancient Celts still have much wisdom to teach us.

Sunrise over Glastonbury Tor and the Somerset Levels.

MINIATURE PICTISH CARVINGS

HE ORIGINS OF the Picts are shrouded in mystery. That they were the inhabitants of northern and eastern Scotland before the coming of the Celts is certain, and their language, which is now completely lost, may well have been passed down from the earlier Bronze Age settlers in these regions. Later Pictish became mixed with the Celtic language, but with the spread and subsequent takeover of the Pictish kingdom by the Scots of Dalriada it vanished into obscurity. Historical facts regarding the Pictish kingdom exist from the mid-sixth to the mid-ninth centuries AD, and at the end of the sixth century it is believed to have stretched as far north as the Orkney Isles. The Pictish King Brude, or Bridei, who died in AD 584, appears in Adamnan's *Life of St Columba*, which was written about a hundred years after the saint's death in AD 597. St Columba ventured into the Pictish kingdom and the court of Brude to effect the king's conversion to Christianity. In 706 Nechtan mac Derelei became king of the Picts. He was less hostile than his predecessors and made contact with Northumbria, including requesting advice on calculating the date of Easter in the Christian calendar. This contact with the Northumbrian Celtic church is nowhere more evident than in the carved Pictish stones, many of which bear a unique mixture of Celtic and original Pictish art. The Celtic side features complex knotwork patterns, as well as other designs similar to those found in the illuminated Gospels of Kells and Lindisfarne, while the Pictish art is nature-orientated and portrays wildlife, such as the bull, the boar, the salmon, the eagle and the stag, as well as mysterious Pictish symbols, which to this day have remained undeciphered. Pictish carvings are technically divided into three groups: Class 1 monuments are those that have only Pictish decoration;

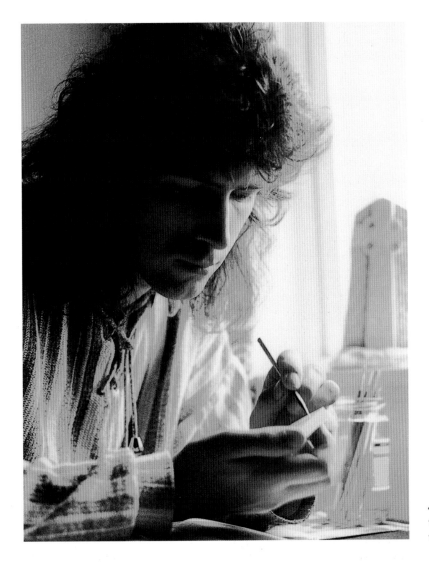

James Gillon-Fergusson at work in his studio carving a miniature Pictish cross.

Class 2 have Pictish decoration as well as a decorated Celtic Christian cross; and Class 3 are decorated with an elaborate cross, but no Pictish symbols as such.

During the mid-ninth century the Pictish kingdom was invaded from the west by the Dalriadic King Kenneth MacAlpin, and the two regions were unified. From this time onwards the Picts as a nation ceased to exist.

Their main legacy today is in the beautiful and extraordinarily detailed Pictish stone carvings, which date from the sixth to the

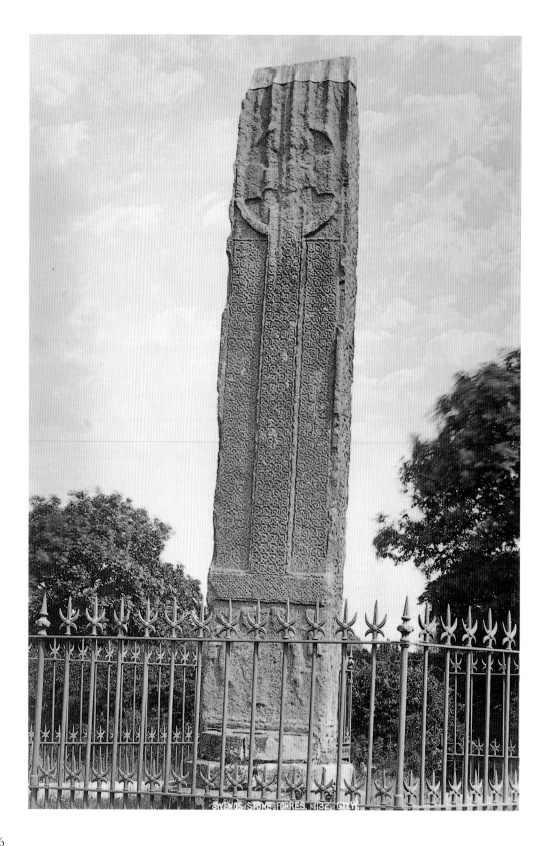

ninth centuries. A number of these can still be found in their original positions. The carving illustrated here is known as the Sueno Stone, and dates from the ninth century. It is categorized as a Class 3 carving and can be seen near Forres in Grampian, northeast Scotland. The photograph, one of the earliest known, was taken about 1897. It clearly shows the highly complex Celtic knotwork patterning on and surrounding the cross, whereas the reverse side (not shown) has panels depicting a battle scene, possibly related to the invasion of the Picts' land by Kenneth MacAlpin. Today the monument stands encased in perspex and glass to protect the fine detail from further erosion.

The miniature sculptures of these ancient stones that are today made by James Gillon-Fergusson in his studio in Dundee have achieved worldwide recognition for their intricacy and exact replication of the original monuments. James grew up in Angus, an ancient area of southern Pictland, where there are many Pictish stone carvings, some of which still feature prominently in the landscape. As a child, he became fascinated by the mystery of these lonely monuments, which had been carved by Pictish sculptors over a thousand years ago.

The tradition of stone carving on the east coast of Scotland was assisted by the plentiful supplies of sandstone, into which they carved the fine detail. Many of these surviving examples of Pictish art are in the distinctive and unusual format of cross-slabs, which create a solid and imposing form, in addition to which the Pictish sculptor carved strange and mysterious symbols. These stones capture the modern imagination, raising questions about a unique culture, their forgotten ways and lost language, and about why the Pictish culture died out, rather than being passed down from generation to generation.

James used to visit the well-known group of Pictish stones at Aberlemno, near Brechin, Tayside, where some stones still stand in their intended positions in the landscape. Captivated by the imagery, he began to convince himself that he could translate the same complex patterns and convey something of their sense of mystery in miniature. For his first subject James chose the Kirkton of Aberlemno Battle Stone, which had captured his imagination and was an obvious choice for many reasons. It is one of the most distinctive Pictish stones, tapering from the bottom upwards towards the apex – the angles are similar to those of a pitched roof, creating a distinctive outline. The cross projects boldly beyond the surrounding panels, creating a further

Opposite: A photograph taken c. 1897 of the ninth-century Pictish Sueno stone at Forres, Morayshire, Scotland. It has highly detailed knotwork patterning. Today this stone is enclosed in a glass/perspex construction to protect it from erosion.

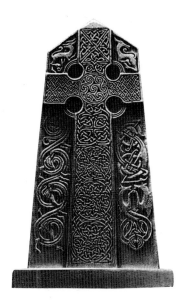

A miniature carving of the eighth/ninth-century Kirkton of Aberlemno Cross by James Gillon-Fergusson.

A miniature carving by James Gillon-Fergusson of the eighth/ninth-century Pictish stone at Kirriemuir in Scotland.

dimension to the form of the stone, and it is covered in the various disciplines of Celtic art: knotwork, spiral and key patterns. The surrounding panels are adorned by curious entwined animals, while on the other side of the stone is a unique depiction of the Battle of Dunnichen (AD685), which was an important victory for the Picts over their Northumbrian aggressors, offering historical insight into the Picts and the inspiration for James to begin the miniature stone.

This was a technically ambitious stone to select, and James spent as much time practising with a variety of tools on sample pieces as he did carving the subject. In time, the necessary skills developed, and the patterns, which at first seemed infinite, soon became an addictive challenge. During the carving of the 8-inch miniature he acquired a variety of tools, many of which would be familiar to any dental technician, that enabled him accurately to create the detail in the more intricate sections of knotwork and, later, to shape character into the more textural and rough appearance of the Pictish symbol stones. When he eventually finished his first stone, the great feeling of accomplishment was, says James, enough reward in itself for those long hours of patient work.

In the summer of 1992 he exhibited a cast of the miniature Aberlemno stone at the annual Pictish Arts Society conference at Letham, in Angus, appropriately held a mile from the ancient battle site at Dunnichen. The miniature drew much favourable attention during the weekend, and James received requests for other stones.

During the following months he took more casts along to local craft fairs and another Pictish Arts Society event, while a few shops began taking one or two pieces. James used his newly acquired experience to carve a range of Pictish stones on a new scale of detail, reducing still further the carvings to minute dimensions and finding inspiration partly in the spirit of miniaturization he saw in the endless detail of the carpet pages in the Book of Kells.

James has since carved a range of a dozen miniature stones. These rarely exceed 3 inches in height, which gives a scale of detail that he has found immensely rewarding, especially as there are no stages in any of the techniques of carving that can be done by machine. The master carving may take up to 200 hours to complete, and before he begins, James gathers reference material to establish whether the miniature is to be a reconstruction of the

original or is to be of the stone in its natural state. Reconstruction is a bit like detective work, involving the collecting of clues in the form of photographs of worn detail on the original stone as well as sketched notes. From these references, a picture of the original patterns or a reconstruction of missing fragments is slowly worked out. This represents a major part of making the miniature, because it was often the fate of the original sculpture to be used as paving slabs or builder's rubble or to have been damaged for religious reasons, and all have suffered the inevitable effects of the weather.

When James has completed the master carving, he can reproduce exactly the same detail in subsequent casts, but at an affordable price. His personal preference is to cast in plaster, which has a natural feel and can be given an effective highlighting technique, creating an unusual photographic impression.

James's partner has become involved in the process, introducing her own thoughts and ideas and dreaming up a range of Pictish pebble pendants and wall plaques. With these additions to their range, their thoughts turned to the Highland Trade Fair at Aviemore, which has become a regular event in their calendar. They have both found it very rewarding to see such widespread interest in their craftwork, and especially in this once neglected subject of the Picts, which is such an integral part of Scotland's heritage.

A miniature of the Glamis Cross by James Gillon-Fergusson.

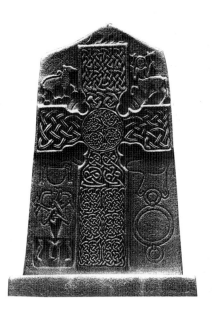

WOODCARVING

OOD HAS BEEN fashioned into both utilitarian and artistic items by the Celts from earliest times. From its basic use as the framework of thatched dwellings (see Iron Age round house construction, page 88). to the building of chariots and boats during the first millennium BC, wood and its source the tree were held in great esteem. Wood was never wasted, because every tree was regarded as sacred, and some, such as the yew, were especially so. In the ancient Irish *Seanchus Mor* it was written that the cutting of even a branch from any of the major species of sacred trees was an offence punishable by death.

Its perishable nature means that few artefacts in wood have survived. A few small wooden figurines from this early period have been excavated in Europe, leaving us to imagine how much beautiful and varied woodcarving from this era must have been lost due to the ravages of time and weather. Many fine wooden artefacts from the Celtic Christian era must have suffered the same fate. Some of the elaborate free-standing Celtic crosses, such as St Martin's ninth-century cross on Iona, have apertures in the arms through which carved wooden extensions would have been fitted on festivals and special days. Unfortunately, the wood itself has long since vanished. In the Celtic monastic period small portable shrines, known as reliquaries, were made to hold the bones or relics of saints. They had an outer casing of metal, often covered with semi-precious stones and gold or enamel ornamentation. The insides of these small caskets were made from wood, and were usually hewn from single pieces of yew, the most sacred of trees, and these beautiful pieces of craftsmanship were regarded with great reverence. Several still exist in Britain, Ireland and Europe. One such is the Monymusk reliquary from Scotland, which dates from the eighth century and is said to have contained relics of St Columba.

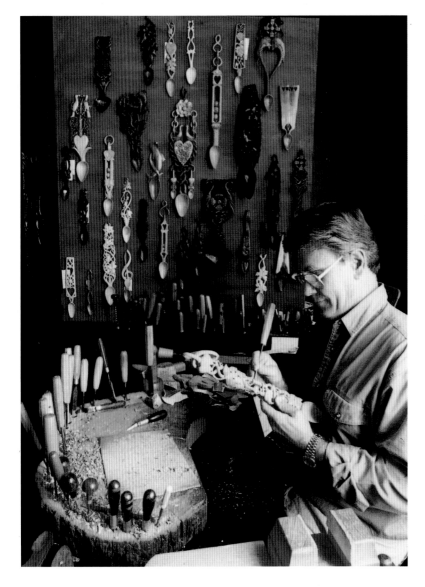

Welsh lovespoon carver, Mike Davies, at work in his studio.

The tradition of woodcarving is kept alive in the Celtic countries by a few dedicated craftspeople, and some beautiful items are still made. These include bowls and platters with knotwork designs carved into them, Celtic crosses, often carved for chapels or churches, and carved wooden sculptures portraying many different subjects, from the Green Man to early goddess figures, Celtic deities and sacred animals.

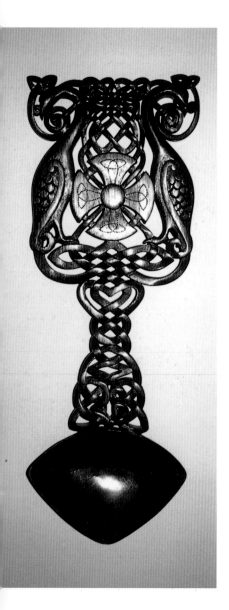

A Welsh lovespoon with an elaborate Celtic design and equi-armed central cross. It is carved from a single piece of mahogany.

One woodcarving tradition that has continued unbroken since its commencement is the craft of the Welsh lovespoon, and the exquisitely detailed work of master-carver Mike Davies has been commissioned for and by many illustrious persons worldwide, including HM Queen Elizabeth II, and ex-president Gorbachev of the former USSR.

After completing his formal studies in art, Mike taught himself to carve wood and, in particular, lovespoons. Being a Welshman working in wood, it was, he says, inevitable that he would eventually carve a lovespoon for both creative and traditional reasons. Some of the earliest examples he carved were for loved ones and members of his family. These early attempts were so well received that he decided to research and study both history and traditions associated with the spoon. At that time there was little written on the subject, so he decided to visit the Welsh Folk Museum at St Fagan's, Cardiff, where there is a wonderful collection of early examples of lovespoons, one example being dated 1667. After many visits to the Welsh Folk Museum spent studying how the spoons were carved and why, Mike realized the potential they offered to express himself creatively and seemingly without limitations, save his own abilities, so he took up the challenge and decided to specialize in carving Welsh lovespoons, in the hope of taking this humble craft into the art world and eventually into galleries the world over. Mike recognized the possibility of combining his love of Celtic art with the format of the spoon. The connection with the Welsh Folk Museum has continued throughout his career, and he has exhibited and demonstrated there on many occasions as well as having received invitations to exhibit and demonstrate around the world.

From the outset Mike made three types of spoon. The first type is designed and carved using traditional symbolism in the true sense of the description Welsh lovespoon. These spoons have to be carved by hand from one solid piece of wood. They have no joins or additions, including the parts that are articulated, chains, loose spheres in a cage and so on, and each spoon carries a message of love or affection or commemorates a special occasion. When he takes a commission to carve this type of spoon, Mike asks his client to supply him with any relevant personal details, including important love, passions or profession in their lives, so that he can take these into account when he designs and carves the spoon. In this way, each spoon is a work of art that is unique to the people concerned.

The second type of spoon is described simply as 'Celtic'. As this suggests, the spoons are designed and carved using entirely Celtic methods and subject matter. Most of the time Mike strives to produce an original Celtic design, but he sometimes carves a design inspired by a piece of ancient Celtic art from, for example, the Book of Kells.

The third type of spoon is not really a lovespoon as such but is simply a decorative spoon using any subject matter that might appeal to Mike or is requested by a client. It could also be a pure free form, exploiting shapes, colours or grain in a particular piece of wood.

Much of the wood that he uses is grown in Britain, and whenever possible, he uses wood from trees that have either fallen in storms or something similar. He dries the wood for three to four years before using it. An average tree will last for many years, and because he is a conservationist at heart, he plants three or four trees for every tree he uses. He prefers to work in hardwoods and uses quite a wide variety, including sycamore, cherry, walnut, pear, apple, holly, box, yew and lime.

Mike is always willing to share with others the skills he has gained and the techniques he has learned over the years. He has taught a number of young assistants and students, many of whom have gone on to become independent woodcarvers in their own right. One of his earliest students was his son, Simon, who sadly died in a tragic accident when he was only eighteen years old. His death had a devastating effect on Mike's life, but the love he has for his work helped him express his feelings in art form, and eventually led to the most productive period in his life. Mike has also been able to help others by teaching at various woodcarving courses and summer schools.

Throughout most of his career Mike has allowed the public into his studio or gallery, enabling them to both watch him carve and also view his work. This, of course, almost always leads to his visitors asking questions both about the execution and the history of his work. Mike finds this interaction stimulating and sometimes inspirational.

A high point of his career was to be invited to be a judge at the 1990 London Woodcarver's Show, which was held at Alexandra Palace, London. As well as exhibiting his work there he also gave a demonstration, which he found to be exhilarating, especially as there was the opportunity to meet so many other woodcarvers. The spoon he used to work on by way of demonstration at this

The 'Tree of Life': Welsh lovespoon made by Mike Davies. The original single piece of wood that this spoon was carved from was three inches thick, and the whole carving took 280 hours to complete.

This Welsh lovespoon by Mike Davies was commissioned for H. M. Queen Elizabeth II in 1993.

show was quite a large and complex piece of work, and it took many hours through the following year to complete, in time to exhibit it at the 1991 London Woodcarver's Show, when he was invited back to judge, exhibit and demonstrate once again.

A great deal of Mike's work is commissioned by people from all walks of life and from all parts of the world. Two of his most notable commissions have been for royalty. The first was in 1990 for H.R.H. Queen Elizabeth, the Queen Mother, and the second, in 1993, was for Her Majesty the Queen. When Mike was commissioned to carve a Welsh lovespoon for the Queen Mother, he was asked to submit a design that would include her flag and in some way symbolize the fact that it was Her Majesty's ninetieth year. He was also asked to include Cardiff's County Coat of Arms. Mike used lime wood because it is a gentle wood in appearance and delicate in colour, which seemed to reflect Her Majesty's character. The overall design is held together with a vine, leaves and fruit, which symbolize a long and fruitful life, and the vine has nine bunches of grapes, one for each decade. At the top of the spoon, which was presented to her during an official visit to Cardiff in 1990, is an *icthus* (fish shape), which symbolizes Her Majesty's Christian faith. The spoon was carved from a single piece of lime wood, 19 inches long and it was finished with a beeswax polish. The spoon carved for Her Majesty the Queen was also from lime wood, and it was made to coincide with a visit to the City of Cardiff, hence the inclusion in the design of the Cardiff County Coat of Arms. This time Mike placed the Arms at the lower part of the spoon. Above this is a Tudor rose entwined with a Welsh daffodil, symbolizing the Queen's connection with Cardiff and Wales, followed by a passage of Celtic knotwork. Mike thought this would be most appropriate because he first saw the design on a cape worn by Henry VIII in a portrait painting by Hans Holbein (1497–1543), which was hanging in the Walker Gallery, Liverpool. Linked to, and above this were the letters ER II (see the illustration on the left).

When he is not working on a particular commission, Mike has complete freedom to produce whatever he wants. He finds that this freedom provides a most welcome and necessary balance from the in-built pressures of commissioned work. It is at these times that he produces the carvings for exhibitions, such as the one organized by the Craft Council together with four city museums and art galleries throughout the UK. It included work by master-carvers from the seventeenth century through to, and

including, many contemporary carvers. This major exhibition toured Britain for twelve months in 1993–4 and contained many exciting and wonderful works of art. Much to Mike's delight, one of his pieces, a fish carved in yew, found its way onto the front cover of *Woodcarver* magazine. Over the years he has taken part in many joint and one-man exhibitions throughout Britain and different parts of Europe, and yet he is, he says, always impatiently looking forward to the next one.

Mike has always studied and observed other European woodcarvers and sculptors and their work, especially that of the ancient Celts, Greeks and Romans as well as of many contemporary craftsworkers. Although he strives to produce work that he believes to be original, he will, on occasion, repeat a piece of work from the past, usually something by an ancient Celtic artist, whose work Mike copies through sheer admiration and in order to continue his learning process.

An opportunity arose in February 1995 for Mike to visit and spend some time with the Maori woodcarvers at their institute in Rotorua, New Zealand. He immediately felt the same deep spirituality in their carving and culture that he senses so strongly when he immerses himself in working with Celtic themes. On route to New Zealand, he stopped in Singapore, and was fortunate enough to spend a little time with a Chinese woodcarver who also produces work that is strongly influenced by his culture and beliefs. Mike was particularly interested in the tools that he used and in his working methods. On the same trip, he also had time to look up two Balinese woodcarving friends on the island of Bali, which abounds with woodcarvers, and he met many, the youngest being only eight years old.

Mike has always loved working in wood, partly because it has given him the means to provide for and take care of those he loves, and partly because it gives immense satisfaction to his deepest creative urges, while at the same time giving pleasure to others.

Several Canadian towns are named after their Scottish (or sometimes Irish and Welsh) counterparts by the early settlers from Celtic countries, who brought with them their culture and customs. The picture is of Mount Cheyenne, which is 7,000 feet high, soon after sunrise. Not far away are the towns of Banff and Calgary, both of which have their Scottish counterparts and were originally given their names by the early settlers. Interest in the Celtic world is increasing throughout Canada, and there are a number of talented craftworkers located in places as far apart as Nova Scotia, on the Atlantic coast, to Vancouver Island on the Pacific west coast. There are also regular Celtic festivals, Gaelic-language establishments, professional musicians and recording artists, such as Canadian-born Loreena McKennitt, whose Celtic roots find expression in her fine music, which has recently become known and appreciated worldwide.

Mount Cheyenne, British Columbia, Canada (7,000 feet). A number of towns in this region have much older counterparts in Scotland with the same names. The Canadian towns were named by early settlers of Celtic origin.

Allen Calvin, of Midland, Ontario, has been artistic all his life, but he discovered the wonder and beauty of the Celtic art form only relatively recently. He now pursues it enthusiastically in his carvings. Allen has always been interested in drawing and, later, in painting. He tells how his father drew cartoon characters for him when he was quite young, and he copied pictures from books. In his early adolescence he became interested in painting, which he thought was a pleasant way to pass time. 'My family felt it wasn't something you did for a living,' he says. 'I grew up with that view.'

During his twenties, he continued to draw and paint, preferring landscapes and portraits. He was fascinated by people's faces: 'the endless variety and expressiveness that is concentrated in that part of the body. I saw faces as maps of who they are, where they have been and what has happened to them. It's all there. It still continues to intrigue me.'

A casual encounter caused Allen to examine his attitude and begin to change it, however. He had finished some drawings, and a stranger asked if he could see them. He looked at them and then asked what Allen was going to do with them. When Allen said he would probably throw them away, the stranger asked if he had ever had any art instruction. Allen said that he had not. Then the stranger said to him: 'You have been given a gift! What are you going to do to develop it? You have a responsibility to develop that gift you have been given.'

Hitherto, Allen had not regarded his talent as a gift and certainly didn't see any value in it. The incident stayed with him for a long time, and he began to look at the talent and his responsibility to it and the value that this talent had. He made a concerted effort to improve his drawing skills and to think about the true nature of art. What is the difference between art and all the other creative things people produce? What is the distinguishing factor?

After nine years in the Canadian military, Allen and his family moved from Ontario to British Columbia, 3,000 miles away. While he was looking for work and adjusting to all the changes, he became friends with a sculptor who, at the time, was working on life-size replicas of killer whales (*Orcas*) for the Vancouver Aquarium. They had a rather casual agreement whereby Allen would do sculpting and his friend would assess what he was doing and make comments. He had been trained in art and worked in a variety of different media, including some wood

Allen Calvin in his studio in Midland Ontario.

carvings, but at the time Allen was not interested in them. He found it quite enjoyable working with clay and producing something that occupied a space as well as making a statement, and he continued to sculpt in clay, then tried metal sculpture with torches and welding machines. Allen liked the effect he got with the metal, although he burned himself frequently by putting his bare hands on the hot metal.

While he worked with the sculptor, Allen was interested to see that he was struggling to make a living with the work he was doing. Even large commissions didn't net much profit. It is a familiar story among artists.

Allen moved back to Ontario, renting a small farm outside Hamilton and settling into the country life. He wanted to play a dulcimer but found they were too expensive, so he decided to build one himself and carve the tuning head. He got some wood from a lumber yard and some tools from a hardware store, and started carving and shaping the tuning head for the instrument. He was quite pleased with the finished head – it sounded excellent and he played it for quite a while. It still hangs on his wall as a decorative piece.

A hinged wooden box with a lid carved with birds and knotwork by Allen Calvin.

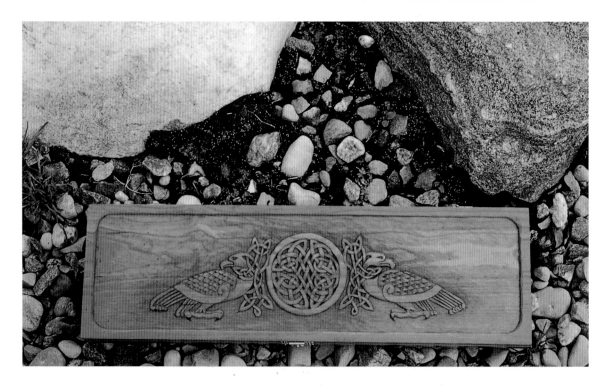

While he was working on that project, Allen discovered how much he enjoyed carving wood. He found the material lovely to work with and that it finished to a beautiful, dazzling effect. He saw that the possibilities were enormous: the material is readily available; there is such a variety of woods to work with, all creating very different effects and results; and the only limits to creativity are self-imposed ones.

Allen purchased some good tools and started reading all the books he could on carving. He attended McMaster University in Hamilton, Ontario, taking art history and studio work, and found that it was a 'luxury' to have time set aside to just draw and think about what art was, as well as working with models. Leaving university, he looked for work at the local steel company, but at the same time there wasn't a day that went by in which he didn't have a carving he was working on or a drawing he was completing. He drew most of the men that he worked with, and continued to hone his carving skills.

One day he received a phone call from a clergyman friend who had been elected a bishop. He called to see if Allen would work with his son, a cabinet-maker, to carve a crozier for his consecration. Allen said he would be honoured to carry out this commission, and they agreed on a regular crozier head with a cluster of grapes hanging down into the main space of the crook, and the vine of the grape twining around the complete length of the shaft. The overall height was about 6 feet 5 inches, and it was carved out of cherry. The time needed to complete the project for the consecration was pressing, and Allen worked on it while he was at work. When his colleagues found out that he had received the commission and how close the deadline was, they told him not to worry about his job being done. They said they would look after it. Allen carved all day long and into the evenings as well. The crozier was divided into three pieces, the head and two shaft pieces, and the cabinet-maker was doing the finishing of the sculptured piece. It was completed the day before the consecration.

They later made a carrying case for the crozier. Allen carved the handle for the case, a tiger on one end and a dragon on the other, and he told the bishop: 'The tiger is the symbol of earthly powers and the dragon is a symbol of heavenly powers, and what you carry in the case is a symbol of the ultimate power. So you have it all in your hand.'

It was at this time that Allen became enchanted with the Celtic art form. He was browsing through a book store when he came

across a children's colouring book on Celtic design. Despite being produced for children, the artwork by Alice Rigan from California was surprisingly detailed, and it was the last copy they had in stock. As he went through the book he became more and more engrossed with the designs she had done. This was a language that spoke about another time and a people who saw the world in a completely different way. Allen found that he wanted to understand this language and to speak it. He also wanted to know what kind of mind had originally created these designs over a thousand years ago, so he acquired a copy of John G. Merce's *A Handbook of Celtic Ornament* (out of print) and George Bain's *Celtic Art: The Method of Construction*. He began to teach himself how to do knotwork and other Celtic designs – a task in itself, he says. As he began to carve the designs, he wrestled with how to use them and where. Drawing and carving designs are one thing, he feels, but understanding them is quite another.

Allen searched through book stores everywhere he went, looking for books on Celtic mythology, Celtic history and Celtic stories. Morgan Llewelyn was a great inspiration, and he found her historical novels very instructive. Every now and then there was mention of the knotwork and designs, with a suggested interpretation of what they meant. 'I always seemed to find enough to whet my appetite but not enough to satisfy my hunger,' Allen remembers. 'I recall one day working at the steel company where I was busily drawing designs into my book. A man I worked with who came from Kuala Lumpur saw what I was doing and remarked that they were Hindu designs. "No," I assured him, "they are Celtic." "No," he said, "those are Hindu mind puzzle designs." I had to agree with him that they certainly were mind puzzles, and in retrospect I see that there is a certain similarity between some Celtic and Indian art.'

All the books he studied and the information he gathered eventually led to a study of the period marked by the turbulent clashes between the beliefs of the Roman Christian church and the pagan Celts. Most of the information he was reading was Celtic, but was usually viewed from a Christian interpretative angle. As an expression of his feelings, he carved Celtic crosses, using the Christian cross with pagan symbols inside it. They were elaborate and took a great deal of time to do, so that he ended up selling them for much less than they were worth.

Allen says that he is emerging from that phase now, as he understands more about the pagan practices and how different

they were from Roman beliefs, which, he feels, seem to stem mainly from the effect of writing things down as opposed to committing everything to memory. The similarity between Celtic pagan spiritual practices and the beliefs of the North American indigenous peoples is quite striking, and Allen has talked with Haida carvers on the west coast of British Columbia about the mythological and spiritual base of their work. The presentation is quite different, but the core from which they draw inspiration has, he finds, similarities to that of the pagan Celts. Allen is still carving crosses, but they are more pagan now, and he draws inspiration from the poems of Taliesin, the *Mabinogion* and *Taín Bó Cuailngé*, as well as the stories of the Tuatha dé Dannan. He thinks he now has a better understanding of what art is and what value and purpose it has.

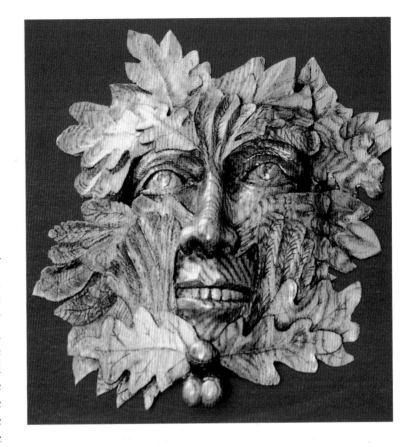

The Green Man: a carving by Allen Calvin. The Green Man is an ancient pagan symbol of the spirit of vegetation and renewal.

Allen would like to find a word other than art to describe the creations that are made by artists and craftworkers. For Allen the pursuit of the Grail, or enlightenment within the Celtic tradition, is the fountain head of his work, most of which is an expression of that journey. The viewer amplifies this pursuit, as long as the piece 'works' for him or her. It is that connection that Allen would call art. It is a reminder that humans are spiritual beings and we do not reach our full potential unless we pay attention to that fact. Art is a constant reminder of our higher nature. As an artist who works primarily with wood, Allen feels a sense of responsibility in endeavouring to give form to an ancient spiritual belief system, which, in the light of our present ecological situation, has possibly even more relevance today than it had in the past.

SLATE CARVING

HE CARVING OF designs onto slate has been part of the Celtic tradition for almost two millennia. Basic and powerful designs have been found in what is now eastern and central Europe dating back to the early Hallstatt era, around 700 BC. Slate is susceptible to the weather, and some of the best examples have been found in protected places such as caves or burial chambers. In some parts of western Scotland, west Wales and Ireland slate occurs in abundance, and the tradition of slate carving was continued throughout the Celtic Christian period. However, harder types of rock, such as granite or Lewissian gneiss, were preferred for the carving of large sculptures like slab crosses and great high crosses because slate is not only prone to erosion by the elements but also fractures easily. Later on, this property of slate gave rise to its widespread use as roofing tiles for traditional crofts and farmhouses in Scotland, Wales and Ireland as well as in Cornwall and on the Isle of Man.

When slate carving is discussed today, one of the best known names on the Isle of Man is Maureen Costain Richards, of Ballabrara Arts, Port St Mary. Maureen was born and bred on the island, and she has devoted her life to the study of the ancient Manx crosses and their complex, intricate designs. In the 1950s, she took a general art course at the Douglas School of Art, where she studied under Eric Houlgrave.

Two factors influenced her future: an interest in the archaeology of the island and her marriage to Harold Richards, who ran his own company Ricardo Crisps. Initially Maureen joined her husband in his business and went around the island, delivering their products to various shops. She was concerned at the quality of souvenirs sold to tourists in many of these shops, finding that many of the items were made in foreign countries and were of poor artistic standard.

With her interest in all things Manx, Maureen began to study the ancient crosses. From the sixth century onwards, the island

had been influenced by travelling Irish monks, some of whom had settled there and built small chapels. They also carved some pure Celtic crosses, such as the one found on the Calf of Man, a tiny island off the southernmost tip of the main island. This is a fine eighth-century example, which can be seen in the Manx Museum, in Douglas. In the early ninth century the Celtic inhabitants of the island were overrun by Viking invaders, whose influence is still strong. As well as being evident in the numerous carved crosses with Norse runic inscriptions, which are unique to the island (there are over 190 crosses, and they are to be found in every parish), the Manx parliament, Tynwald, was instituted by the Vikings, and in 1979 it celebrated one thousand years.

Maureen discovered in the Manx crosses a rich heritage, with a wide selection of Norse-inspired dragon designs. There was only one reference book on these crosses, written in 1907 by P.M.C. Kermode, a pioneering gentleman who had managed to rescue

Maureen Costain Richards at work in her studio, Ballabrara Arts, Port St Mary on the Isle of Man.

73

many of them, which he found had been used in churchyards as gravestones, in church buildings as lintels and even as doorsteps.

Undertaking a task that took many years, Maureen visited all the island's churches and made drawings of the existing crosses. These designs were eventually published in 1988 in her book *The Manx Crosses Illuminated*. This is the only book of its kind to incorporate all the Manx crosses, and it is a tribute to Maureen's lifelong dedication and artistic skill. Of the book she says: 'It is not a historic dissertation by any means. We have a wonderful heritage in these crosses – they are the only ancient art the island has. There were no illustrated books before 1511 that we know of, no illuminated books like the Books of Kells and Lindisfarne, so they are of enormous importance.'

Also at this time Maureen opened her shop, Ballabrara Arts, in Port St Mary. The name derives from the Gaelic *balley braarey*, meaning 'estate of the monks', and she chose the name because monks were famous for, among other things, their craftwork. She began experimenting with pewter, copper and, especially, slate, and her first work was a reproduction of the ancient Ballaugh Cross. Today she says that every piece amazes her as it takes shape, and every one is hand-finished. She finds inspiration in many of the crosses she visited and illustrated for her book, including the tenth-century Lonan Cross, located above Laxey Bay on the east coast of the island.

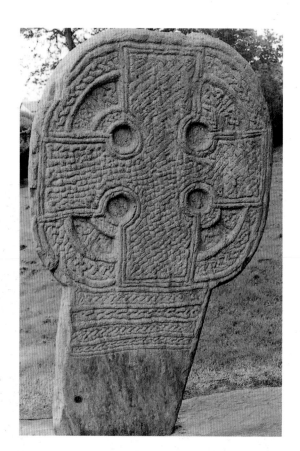

The tenth-century Lonan Cross on the Isle of Man.

Her small, compact workshop is behind the shop. It contains a bewildering array of tools, all within easy reach, many of which are dental tools, which are ideal for working on slate and other media in a detailed manner. The only design she uses apart from the crosses is the Trie Cassyn or Three Legs, the symbol of the Isle of Man. It is thought that this symbol first appeared in the thirteenth century, but from where and how it came is a mystery. Some say that it came from Sicily, and others say that it developed from the triple knot that is found on so many Manx stone crosses.

It has also been called a solar wheel, and may well have once been a symbol of pagan sun worship.

Maureen's workshop is in use every day and all day, and she often continues work up in her flat during the evening. Over the years her carvings have received international acclaim, and she has carried out many commissions for well-known people. One such was H.R.H. Princess Anne, who visited the Isle of Man in October 1984. Maureen was commissioned to carve a replica of the Calf of Man cross for the Princess, which she did using Manx slate, the finished carving measuring 8 by 7 inches. This was only the second ever replica of this cross to be executed by a contemporary sculptor, the first, also carved in Manx slate by Maureen, having been presented to Princess Alexandra in July 1983. One of

Maureen Costain Richards carving a replica of a Manx cross in slate.

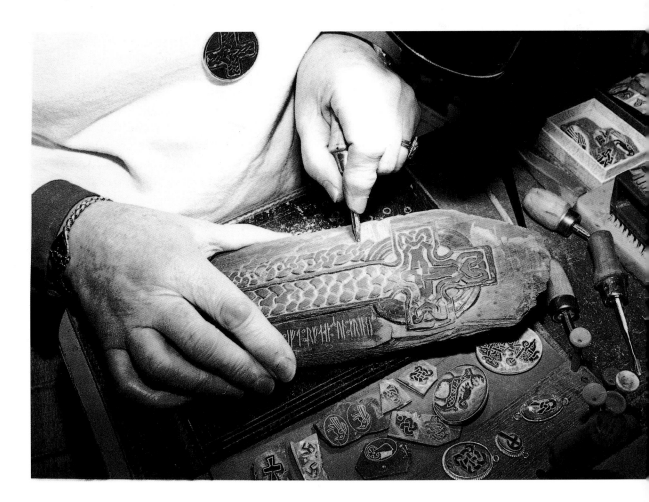

Reih Bleeaney Vanannan

Reih Bleeaney Vanannan is the national honour
Ta Reih Bleeaney Vanannan yn onnor ashoonagh
for an outstanding contribution to Manx Culture
er hon cohoyrtys ardjindyssagh gys Cultoor
established in 1986, Manx Heritage Year, under
Vannin, currit er bun ayns 1986, y Vlein Eiraght,
the auspices of Yn Cruinnaght' and the Manx
Vannin fo coadey Yn Cruinnaght as Undinys
Heritage Foundation. It is represented by a
Eiraght Vannin. Teh er'n hoilshaghey magh
of Mananan, the Celtic Patron of the Arts designed
ayns jallooeen jeh Mananan, Ard-charrey ny
by Eric Austwick, and donated by Stephen
Seyr-ellynyn Celtiagh, kiadit ec Eric Austwick
Quayle, set on a base of Pooyll Vaish marble
as toyrtit ec Stephen Quayle, soiet er bun jeh mar-
which also incorporates items of the natural Manx
mur Pooyll Vaish lesh meeryn meaynin doo-
minerals, quartz, lead and Laxey silver
ghyssagh Vannin, clagh-greiney, leoaie as argid
The award is made annually by a panel of judges
Laxa. Bee yn aundyr sho jeant dagh blein er hon panel
consisting of the Chairman of the Heritage Found-
briwnyn, jeant seose, jeh yn Ard-hoiedeyr Undinys
ation, the Chairman of the Manx Museum and
Eiraght Vannin, yn Ard-hoiedeyr Thie-tashtee
National Trust, the Chairman of the Isle of Man
as Treisht Ashoonagh Vannin yn Ard-hoiedeyr
Arts Council, the President of Yn Chruinnaght'
Conseil ny h'Ellynyn Ellan Vannin yn Eaghterane yn
Trust, the President of Yn Cheshaght Ghailckagh,
Chruinnaght, yn Eaghterane Yn Cheshaght Ghailckagh,
and Mr. Stephen Quayle
as Mainshtyr Stephen Quayle

REIH BLEEANEY VANANNAN 1986 HAS BEEN AWARDED TO
TA REIH BLEEANEY VANAN NAN 1986 ER'N CHURDA

·MAUREEN·COSTAIN·RICHARDS·

Signatures of members of the panel of judges
Cowraghyn jeh oltyn jeh'n panel briwnyn

CHAIRMAN OF THE
MANX HERITAGE
FOUNDATION

PRESIDENT OF
YN CHRUINNAGHT

CHAIRMAN OF THE
MANX MUSEUM
& NATIONAL TRUST

PRESIDENT OF
YN CHESHAGHT
GHAILCKAGHT

CHAIRMAN OF THE
ISLE OF MAN
ARTS COUNCIL

Compiled with Manx translation by Mona Douglas, Written out by Eric J. Houlgrave, Trophy assembled by D. Gregg, Scroll-case by Arnold Saddlery.

her elaborate carvings was also given to Prince Edward during a visit by him to the island. Another commission that she enjoyed creating was a statue of St Bridget, which was presented to the Duchess of Kent for St Bridget's Hospice.

In 1986 Maureen was the first winner of the Reih Bleeaney Vanannan Trophy, which was given by the Manx Heritage Foundation in Heritage Year. In the local Gaelic-based language this trophy is known as 'Manannan's Choice of the Year', and it is awarded for an outstanding contribution to Manx cultural heritage. Maureen received it for her book *The Manx Crosses Illuminated* and for the years of work that had gone into the drawings of all the ancient Manx crosses contained in the book. She herself had a part in the design of the trophy. The bronze statue of the god Manannan, which was designed by Celtic artist Eric Austwick, was mounted on a marble base incorporating Manx quartz made by local craftsman David Gregg, and this had a slate carving of the eleventh-century Thorwald's Cross set on one side of the base. Receiving this trophy means that Maureen is one of the very few craftworkers and artists to be able to use the letters R.B.V. (Reih Bleeaney Vanannan) after her name.

The Reih Bleeaney Vanannan parchment awarded to Maureen Costain Richards in 1986.

In 1987 she designed a trophy that is presented annually to the winner of one of the Junior Classes at Yn Chruinnaght, the annual gathering of Celtic people held in Ramsey. People from all the Celtic countries attend this week of traditional music, poetry, dancing and art, which was first held in the 1920s. The trophy, commissioned by the St Ninian's High School Association, is made in Manx slate with the school crest, inlaid with a dragon-headed Viking ship in full sail and with Thorwald's Cross inset in pewter. The base is made of black Manx marble.

Another design that gave her great pleasure is a shield for the Costain family. When the voyage of *Odin's Raven*, a replica Viking ship built in Norway, was planned to mark the millenary celebrations of Tynwald, members of the Costain family in the Isle of Man contacted as many members of the large Costain family throughout the world as they could and raised £1,700 in sponsorship towards the voyage. Maureen designed a Costain shield for the boat. The name Costain is derived from the original Norse name Thorstein.

Maureen's designs are only on sale at her shop in Port St Mary, and she can be seen working at her shop/studio bench during opening hours. Her work, however, has travelled world-wide, as has her reputation as a major contributor to traditional Manx art and design. She is happy to work day and night to promote the traditions and heritage of the Isle of Man, and she has made a tremendous contribution to the awakening of interest in the great treasures the island possesses, the ancient and unique Manx crosses.

Maureen Costain Richards at the Reih Bleeaney Vanannan award ceremony with her trophy from the Manx Heritage Foundation for her work on Manx crosses.

MUSICAL INSTRUMENT MAKING

HERE ARE A number of different musical instruments associated with the Celtic countries, including Scottish bagpipes, the Breton bombarde, Irish and Northumbrian pipes, flutes and whistles of many shapes and sizes, and accordians.

In early Irish history the drum or bodhran would have had a role in warfare, and it is also known that, in more recent centuries, Gaelic chieftains had their own distinctive marching tunes. The harp is another ancient instrument, and its representation and music in early Irish legends and mythology is well known. The actual origins of the harp are obscure. According to legend it is possible that the instrument originated in Greece and found its way to the Celtic lands via the Tuatha dé Danann, an ancient race of powerful people said in early writings to have lived in the area surrounding what is now Athens. Following an invasion from Syria they were forced to flee westwards across Europe, finally settling in Ireland.

Both instruments – the bodhran and the harp – are being made in traditional ways and played by musicians who perform today.

THE BODHRAN

One instrument with an ancient history is the Irish bodhran, whose name derives from the Old Irish word *bodhar*, which means 'deaf' or 'haunted'. There are various theories about how the bodhran first appeared in Ireland. Some say that it has its

origins as a skin tray for collecting peat from the peat bogs for the winter fireplace.

It should also be noted that the bodhran is remarkably similar to the skin tray used for centuries on crofts not only in Ireland but in other Celtic counties for separating chaff from grain. In remote areas of western Ireland and the Scottish islands, this agricultural implement was still in use during the first decades of this century. Other researchers say that the drum originated in Africa and came to Ireland by way of Spain. There is also a theory that it originated in central Asia and was brought to Ireland by migrant Celts, and as some Celts are known to have used stretched leather shields in battle, this idea cannot be discounted. On a more humorous level, a local folk legend says that it was made by cunning Kerrymen to push up the price of goatskin. Whatever its ancient origins may be, the bodhran is most definitely at the heart of Irish music today. The craft of bodhran making is highly skilled, and few workers in this craft still use traditional methods. One remarkable workshop where traditional bodhrans are made on a full-time basis is on the west coast of Ireland, where Malachy 'Bodhran' Kearns and his wife Anne run Roundstone Musical Instruments.

Malachy has been accepted as a renowned bodhran maker for almost twenty years, and most professional musicians worldwide who incorporate the bodhran in their music find their way to the Roundstone workshop. Such names as Planxty, the Chieftains and De Danann have all chosen instruments from Malachy's workshop, and one of Malachy's recent commissions was to make the bodhrans and larger drums for the highly successful Irish music and dance group Riverdance, which has been on tour worldwide performing to sell-out audiences.

The Roundstone workshop, which is set in the wild and idyllic Connemara countryside, was previously part of a Franciscan monastery, built in 1831. Roundstone itself lies on the western arm of Bertaghboy Bay and is 48 miles west of Galway. The village is beautifully set on one of the most spectacular coastal drives in Europe, overlooking the Atlantic at the foot of Errisbeg Mountain, from the summit of which is a panoramic view of Connemara lakelands, mountains and sea. Close to the village the unique Roundstone bog is rich in plants and features of botanical and historical interest. The annual salmon and lobster festival, held in late June, and the regatta, held in July, are both venues for fine traditional music as well as street dancing and traditional games.

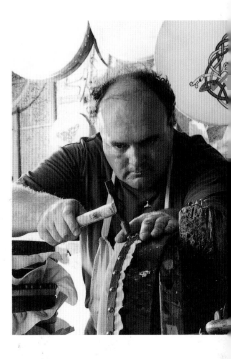

Malachy 'Bodhran' Kearns at work making bodhrans. His workshop is on the site of an old Franciscan monastery at Roundstone, County Galway, Eire.

Close to the workshop, a view across the wild Connemara Countryside.

Malachy Kearns testing a bodhran for 'the deeper side of sound'.

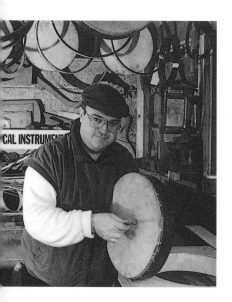

Of his craft, Malachy says: 'The process of making bodhrans is very close to nature. The instrument when played is very freeing for the soul, and the whole involvement has a very spiritual experience to it.' His workshop is an Aladdin's Cave for anyone interested in the crafts tradition. The skins he prefers to use for his bodhrans are goat and deer; greyhound and donkey hides are also good. The skins are cured in hydrated lime, mixed with ingredients that remain a close secret, and thus cured they will keep indefinitely. They are then soaked for seven to ten days in a solution of lime sulphide, which softens the skin and partially dissolves the fatty tissue so that fat and hair can be easily removed with a scraper. The skins used expand and contract slightly as the temperature changes, and they have an infinite variety of subtle 'veining'. Consequently, the rich lustre of the instrument becomes more beautiful with age.

After the skin has been stretched on a frame for two or three days and scraped again, a portion of it is removed and tacked under tension to the beechwood frame of the bodhran, using brass upholstery nails. As an added precaution, it is also glued. Next, the cross-pieces are fitted. The wooden beater can then be turned on a lathe from holly, oak, beech or even larch.

In the hands of a skilled player the bodhran can be a subtle and exciting instrument. The skin is struck in a variety of ways, even with the heel of the hand and fingers. The instrument is supported on a hand that is tucked in behind the cross-piece, and this hand is used to vary the colour and intensity of the sound by

pressing on the skin. The side of the beater is also used to good effect on the wooden rim. Malachy has made many different types of bodhrans over the years, even a double-sided one for a French percussion school. The instruments from Roundstone are exported to the United States, Canada and Australia. Malachy's wife Anne is a talented artist and an expert on heraldry, and the bodhrans can be hand-painted by her to the purchaser's choice. Designs from the Book of Kells and other sources are often used, as are family crests. It is also possible to have the name of the child of the purchaser painted onto the bodhran in old Gaelic script.

Malachy's craft is the continuation of a tradition that has remained alive for centuries, and his instruments are the pride and joy of many highly acclaimed folk-musicians worldwide. 'When I hear one of my bodhrans being played by any of the many traditional musicians who play them, such as Riverdance, the Chieftains, or Planxty, I know exactly what they mean when they say that the bodhran is the pulse of Irish music,' he says.

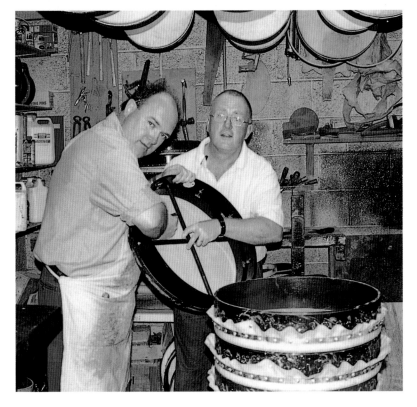

Malachy Kearns and Christy Moore in the workshop at Roundstone. Christy is a bodhran player and a member of the Irish folk group Planxty.

THE HARP

The perishable nature of the materials used to make harps means that the earliest surviving examples of small brass-strung Celtic harps date from the fourteenth century. There is a fine example from this date in the museum of Trinity College, Dublin. An earlier small Celtic harp, which would originally have been gut-strung, is said to have belonged to the Irish king Brian Boiroihme, or Brian Boru (Boru-meaning bear), who was born in AD 926.

A 47-string pedal harp with traditional decoration, by Camac Production, Mouzeil, France.

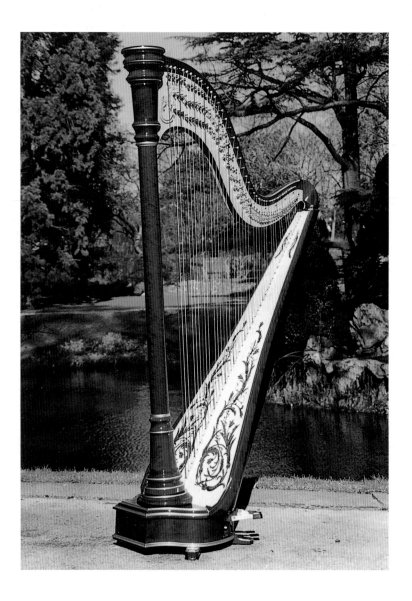

Stone carvings dating from the eighth and ninth centuries from both Pictish and Irish lands depict the harp. In the churchyard of Ullard in County Kilkenny, Ireland, a seated harp player is carved on an early Celtic cross dating from AD 800–830. There is also mention of the use of brass-strung harps in the diary of Geraldus Cambrensis (Gerald of Wales), who travelled through Ireland in the late twelfth century. In 1995 the BBC television archaeology programme *Time Team* travelled to the Isle of Islay, off the west coast of Scotland. During excavations at Finlaggan, once the venerated seat of the Lords of the Isles, some metal tuning-pegs from an early harp were found, while other early carvings incorporating the harp can be found on the island of Iona, where there are thirteenth-century examples in St Oran's chapel and also in Iona Abbey itself.

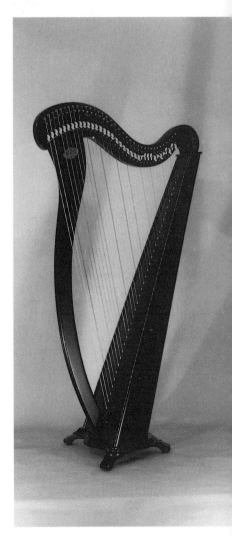

A Celtic harp designed by Camac Production.

Today the harp is enjoying a huge revival, and there are makers of various styles of early harps in all the Celtic countries and in North America. Harp tuition, courses and festivals are increasing in number, and Celtic harps are now even available in kit form, an excellent idea, which brings the purchaser closer to the original methods of harp construction, as well as considerably reducing the price compared with buying a finished instrument. The craft of high-quality harp making takes many years to perfect, however, and the finish of an instrument built by professionals with years of experience will, inevitably, surpass that of a harp built by a novice from a kit.

Magazines devoted to the harp are also available: One of the best for those interested in the Celtic harp is the Scottish *Sounding Strings*. There is also a successful annual festival in Switzerland called Celtic Days, which not only brings together the leading harpists from all the Celtic countries and further afield, but also incorporates arts and crafts. It is directed by the Swiss Celtic harpist and teacher Kora Wüthier from Rorschach. The festival, which was first held in 1994, is ever increasing in popularity. The venue is interesting, too, as it is in the main area of La Tène Celtic culture.

Mouzeil in France is the home of Camac Production, harp makers with many years' experience. The Breton-influenced business was founded by Joël Garnier and Jakez François. Jakez comes from a family of Breton musicians, and a friend of the family, the well-known Breton harpist Alan Stivell, introduced him to the Celtic harp. Jakez studied classical music at the

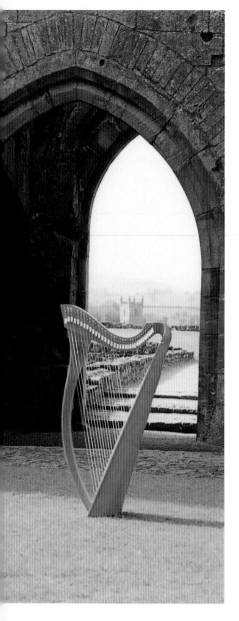

Celtic harps are produced in a variety of designs, both traditional and modern; by Camac Production.

Conservatories of Nantes and Tours, before moving to Boulogne, where he won first prize in the harp class. He then studied under Mmes Breissac, Bouchard and Fontaine and had the opportunity of advice from Gerard Devos and Catherine Michel. These different teachers and the many contacts he has subsequently been able to make with notable harpists and instructors resulted in his developing a technique that has evolved from the various schools of harp playing with which he has been involved. Alongside his studies of the classical harp he has specialized in the Celtic harp, for which he has been awarded the gold medal of the Conservatory of Nantes, the first prize in festivals at Kan ar Bobl and Dinan, and the world trophy for the Celtic harp. Jakez is both a composer and an improviser. He takes an active part in workshops for improvisation on the harp, as well as in the European training courses in harp improvisation in Lyon. He has won many awards for both composition and improvisation, and has already been awarded with a Commande d'État for the composition of a work for solo harp.

For the last few years, however, Jakez has been involved with harps in a quite different way, for he is now commercial director of Camac Production. His training as a harpist, together with his collaboration with Joël Garnier, from whose experience he benefits, has made him a particularly knowledgeable spokesman among harpists and their pupils.

Joël Garnier, the other main influence in Camac Production, started his career as an electronics expert in the navy, including two years at the Research Centre for Special Machinery in the Île de Levant. When he was twenty-three he joined a large US company, but in 1972 he and his musician brother founded Camac, which rapidly became one of the leading makers of traditional musical instruments, including the Breton bombarde. Towards the end of the 1970s he came across the harp and immediately developed a passion for the instrument. In 1985, so that he could pursue his enthusiasm for the instrument, he founded Camac Production, which is entirely devoted to the making of harps. At the World Congress in Vienna he introduced the first concert harp to be made in France since the early days of the famous harp maker, Erard, and in 1990 he designed and created La Bleue, the first electric-acoustic harp, for the World Congress in Paris. In 1996 Joël made a new concept of the instrument available to harpists, called New Generation, which represents the fruits of

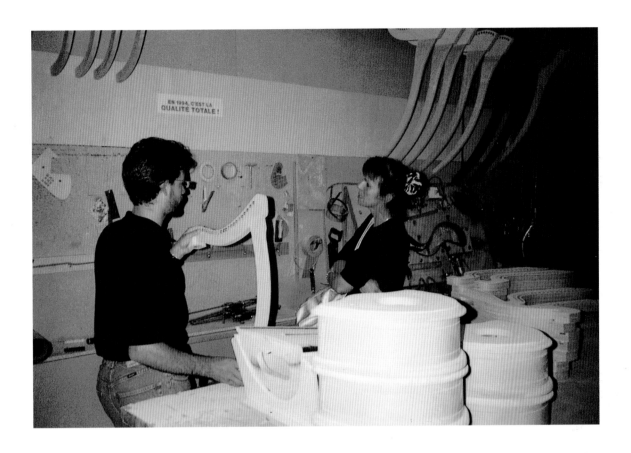

ten years of research. Camac produces fine Celtic harps in various styles, from the traditional to the more modern, and by 1991 it had become the leading maker of harps in France, employing a staff of forty in its workshops. Today, due to the rise in popularity of the harp, Camac Production occupies over 2,400 square yards of workshops and offices, and employs many skilled craftworkers, all dedicated to the construction, finishing and marketing of high-quality harps. In 1995 the Camac Harp Centre near Paris was established, and here the entire range of harps can be tried out.

The workshop at Camac Production in Mouzeil.

IRON AGE ROUND HOUSES

I T WOULD SEEM appropriate in a book of traditional Celtic crafts to mention, if only briefly, one of the main types of Celtic dwelling, the Iron Age round house. Numerous examples were built throughout Europe and in Britain and Ireland during the latter half of the first millennium BC. When Julius Caesar arrived in southern Britain just before the Roman Conquest he described the population of the country as being 'infinite' – certainly an exaggeration, but it does give us reason to believe that southern Britain was not sparsely populated, as some historians would have us believe.

From archaeological excavations of settlements a reasonably accurate picture has been built up of the way in which round houses were constructed. Today, a number of accurate reconstructions have been created, from replicas of single dwellings to complete Celtic settlements. Almost all these sites are open to the public, and they offer valuable information and insights about life in the Iron Age. Notable examples are the Iron Age lakeside village at the Craggaunowen Project, in County Clare, Eire, which also includes a ring-fort and a stretch of Iron Age timbered road, as well as Tim Severin's leather-covered boat in which he and his crew crossed the Atlantic in 1976–7. The Craggaunowen Project also contains a number of fine reconstructions of Iron Age round houses.

The construction of these small dwellings was very much a craft in its own right, and it has been carefully replicated today using all the original materials. The reconstructed Iron Age village at Castell Henllys in Dyfed, west Wales, contains fine examples of round houses. The one in the photograph on page 88 is half-completed and gives a good idea of the skills involved in

building these dwellings. Although there are some slight variations in design, the dwellings follow a basic construction method. The earlier versions had a central pole to which the radial roof timbers were attached. Later versions used more radial timbers in order to distribute the weight of the thatch more evenly – when it is wet, thatch is extraordinarily heavy! A few examples have been excavated, such as the large round house at Little Woodbury, Wiltshire, which has two concentric rings of post holes, and would thus have had two entrance doors. In effect, it was a fire-door system, with the outer door being closed before the inner one was opened to prevent the wind blowing sparks from the central fire onto the interior of the thatching. Another slight variation was the construction of a raised floor, enabling the occupants to live a few feet above ground level. In prolonged spells of damp weather this arrangement would have made living in a round house a much more attractive proposition.

Iron Age round houses at the Craggaunowen Project in County Clare, Eire.

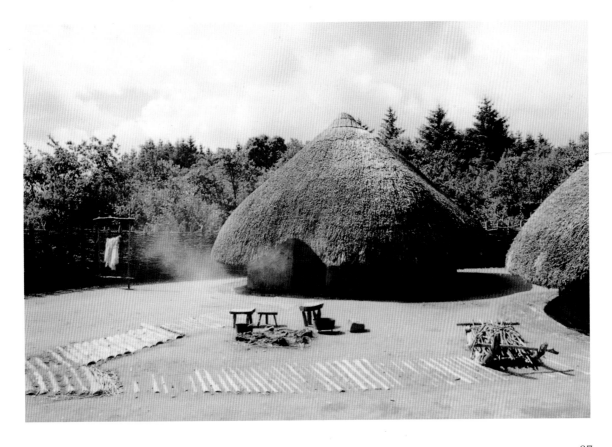

Round house under construction at Castell Henllys in Dyfed, west Wales. It has a diameter of 30 feet and is thatched with reed from a local estuary.

If we look again at the half-constructed dwelling at Castell Henllys, we will see that strong, equal-length timbers needed to be chosen for the roof-radials, which were then lashed together at the top of the 'cone' with pieces of animal skin or supple withies, which are just as strong. These radial timbers were secured by the same means at the other end to the top circle of the upright posts, so that a gap of approximately 3 feet was left between them and the ground. The upright posts, set firmly into the ground at an

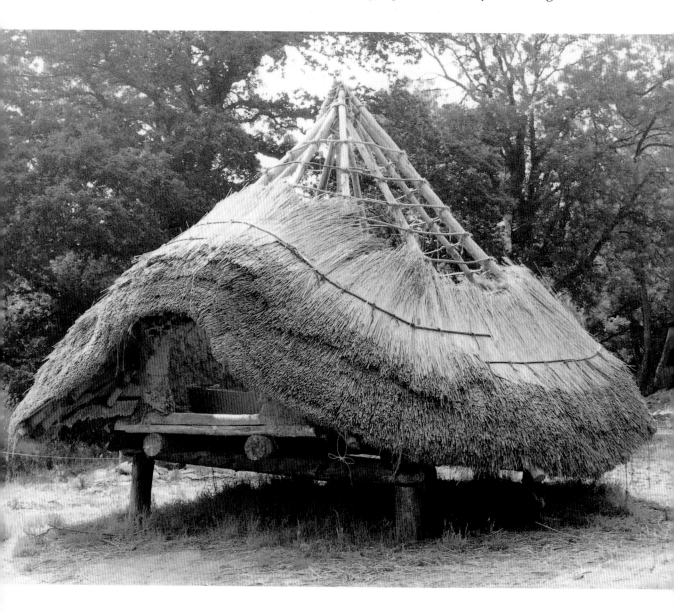

equal height, were the foundations of the dwelling, and they were carefully positioned in an accurate circle before work on the main structure was begun. Many sites of actual post holes have been excavated, the number of posts used varying according to the size of the dwelling. The gap between the bottom of the thatch and the ground was made into a reasonably solid circular wall by weaving hazel withies in and out of the upright posts, leaving a wooden framework for the door. The withies were then covered with a moist, clay-based earth mixed with horse hair and cow dung, in the 'wattle and daub' principle, which dried soon after application. Tacitus, the Roman historian, says that the low walls of identical round houses in Germany were painted, and it seems more than likely that, given the Celts' flamboyant character and love of colour, this practice would have been followed in Britain and Ireland, too.

Finally, the houses were thatched with reeds, starting from the base of the radials and ending at the top of the 'cone'. Concentric circles of thin, pliable withies were lashed in place around the radials at intervals of about a foot, from the bottom to the top of the cone. These gave further support for the weight of the thatch as well as offering points at which the shaped hazel thatching-spars could be secured. In some round houses a small hole was left at the top of the 'cone' as an outlet for the smoke from the fire within. Anyone who has watched a thatcher at work will appreciate the skill involved, and the basic process, tools and methods have remained unchanged since the days of Iron Age dwellings.

The original round houses – occasionally rectangular examples have been excavated, but they are few and far between – were built in lowland regions where material for thatching was abundant. In windswept and barren areas, such as northern and western Scotland, the west coast of Ireland and its islands, and Cornwall, stone replaced wood as a building material, and often the dwellings were constructed partially underground as a protection against the elements.

Fascinating Iron Age settlement reconstructions can also be found at the Welsh Folk Museum, St Fagans, near Cardiff, and also at New Barn Field Centre, Bradford Peverell, Dorset, which is near to Maiden Castle, the largest Iron Age hillfort in Europe. Most of these contemporary centres produce informative literature on how the occupants lived, and these are extremely useful introductions to the lifestyle of the Celts and earlier Iron Age occupants of these lands.

POTTERY

HE FIRING OF clay was well known to the early Celts in Europe, Britain and Ireland. Examples of pottery artefacts, dating from the first millennium BC, range from beads to animal sculptures, and from funerary urns to miniature chariot sculptures and small goddess figures.

Today a few potters still use traditional methods and apply Celtic and related designs to their work, and one of these is James Murray, who has a pottery workshop and shop in Glenarm, County Antrim, on the northeast coast of Ireland. Much of Glenarm pottery is decorated with Celtic designs, and James largely follows the living traditions of his Celtic predecessors.

Glenarm is a quiet country village set in a conservation area. All the buildings are listed, and the Georgian houses, which were once part of a thriving town, are preserved. Signs of Glenarm's colourful past are hard to see now, but it is reported to have been granted a municipal charter by John, who was king of England at the beginning of the thirteenth century, making it one of the first important towns in Ulster.

The house that is now Glenarm Pottery was the last house in the village to be owned by the Earl of Antrim. It is Georgian in date and stands right beside the entrance to the forest. The ground floor is now the showrooms, while the upper floor provides the living accommodation. Glenarm is a beautiful place to live and work, and the rich history provides much inspiration for the pottery.

There was a Stone Age settlement near Glenarm, and these very early settlements and the arrival of the Celts are the main influences on the work of Glenarm Pottery. Tons of flint weapons were found at Cloney beach near Glenarm and Curran in Larne, giving the name Larnian to this period in Irish Mesolithic history. The earliest pieces of pottery, which date from approximately 6000 BC, were found during an excavation at Cloney beach. More pottery was found from the Bronze Age in the hills behind the village. It

James Murray of Glenarm Pottery, County Antrim, Northern Ireland.

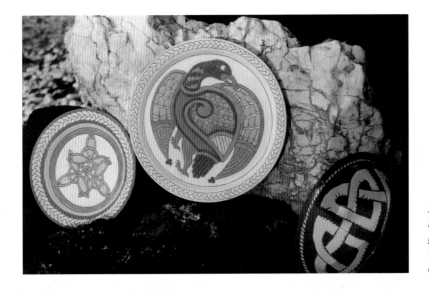

Pottery plates and bowls with sgraffito decoration and under-glaze colours by James Murray; inspired by the Book of Kells and Celtic knotwork designs.

would appear that there was a major settlement here as ancient man moved up from the coast. A henge (ritual enclosure) discovered in the castle grounds, dating from 2500–1500 BC, has not yet been excavated but is believed to be ceremonial.

These sites are not easily visited, but the Glenarm parish is rich with raths and souterrains, standing stones and ancient churches. Many raths or cashels – stone circles built around homesteads as a means of fortification – can be identified from the town names, such as those containing 'dun', 'lios' and 'forth'. A homestead of this type usually had a souterrain, which was an underground stone house used mainly during Viking raids, which occurred here in the eighth and ninth centuries. The latest souterrain to be discovered was at Dickeystown, just behind Glenarm. It has dry stone walls, a stone slab ceiling and earth floors. Some souterrains can be visited, and all are marked on Ordnance Survey maps.

Standing stones are prolific in the area, and great mysteries surround these markers. Some believe them to plot the many ley lines that run through the land; others say that they are 'headstones' for ancient clan chieftains. Evidence has been produced to support both these claims, but the best explanation so far is that they became burial sites after their primary astronomical use was forgotten.

Cairns are also prominent features in the countryside. These burial mounds vary enormously in date, from the Bronze Age to as late as the sixteenth century. The body was cremated and

placed in a clay urn which was put in a stone-lined grave and roofed with stones. The cairns vary in size, probably depending on the wealth and importance of the deceased family.

The actual arrival date of the Celts in Ireland is still debated, but most people agree that it was around 700 BC. They were warfaring people, who imposed their authority on local clan kings. Niall of the Nine Hostages is traditionally believed to be the first high king (Ard-Ri) of Ireland, who ruled over all the clans from his seat at Tara. Tara is the lost fifth province of Ireland, and it is generally believed that the centre of this most important of royal courts is on the Hill of Tara in County Meath. How far this province reached is not known, and it has now been swallowed up by the other four provinces – Ulster, Leinster, Munster and Connaught. Although they were invaders, the rich culture the Celts brought with them gave the early Irish new skills in metalwork, jewellery and weaponry.

The most intricate artwork was done by the early Celtic Christian monks in recording biblical works and teachings. The most famous of these is probably the Book of Kells which, together with other illuminated Gospels such as the Book of Durrow, has become the main source of Celtic illustrations today.

Examples of James Murray's earthenware pottery with elaborate Celtic designs.

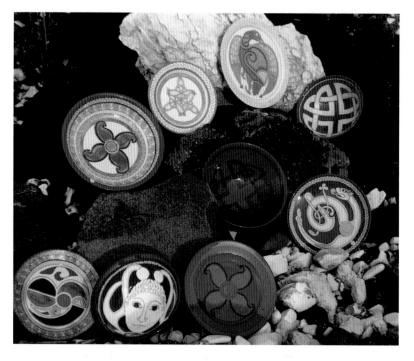

The intertwining patterns and figures are symbolic of the flow of energy thoughout all life – beasts, man and earth. These are designs that never age and are always breathing new life, and much inspiration for Glenarm Pottery's designs is derived from these illuminated manuscripts.

James Murray lived in New Zealand, where he joined a pottery club, which taught him techniques and skills that would change the course of his life. A few years after he returned to Ireland, he started pottery as a hobby. After much practice, he began to sell his work in Larne, and this proved so successful that he was encouraged to start potting full time. Eventually, he and his family moved to the present workshop in Glenarm.

James says that they gain most pleasure from producing practical domestic ware, because they like to see their products being used and appreciated. The main ranges are cobalt blue spongeware, honey slip-trailed ware and a variety of sgraffito bowls and plates. The blue spongeware is a range that has withstood the test of time. Blue is a classic colour, used from Willow Pattern to Dutch Delft and Wedgwood. The clean, crisp colour is applied using sponges, similar to the traditional method of potato printing, a technique commonly used on old pottery from the area. A honey colour is another favourite, derived from an old English tradition, and has a richer quality than other glazes.

The Pottery's specialist range is the delicate and beautiful sgraffito work, by which designs are hand-carved into a clay slip. It is a painstaking process, but the results are magnificent. The shapes of the plates and bowls are left simple to make the most of some of the more intricate designs. These are gathered from many sources but all have meaning and history. Some have been adapted from the Book of Kells, but others are from artefacts found at burial and ceremonial sites throughout the Celtic world. Many are original and unique designs, personal to James, who says that he always allows the ancient cultures to influence him.

The sgraffito technique involves coating a 'green' or unfired bowl or plate with a coating of liquid clay, known as slip. The designs are etched through different coloured layers, which is a technique that allows much detail and accuracy with the more intricate designs. Colourful underglaze stains are then applied before biscuit firing, then glaze firing the pieces. All this is a time-consuming process, as everything is carried out by hand, but James believes in the hand-made aspect of the pottery and will continue to hand-work all the wares from the potter's wheel to the display shelf, as has been done for many, many years.

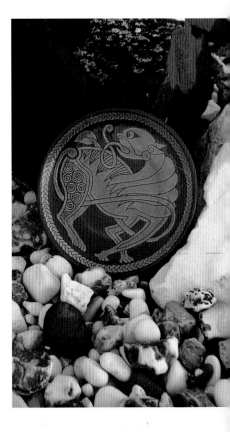

Hand-decorated pottery plate by James Murray with a Celtic dragon and knotwork border, based on motifs in the Book of Durrow.

LEATHERWORK

T HE USE OF leather was an integral part of many early cultures, and the Celts were no exception, although in these early times it was more functional than decorative – some Celtic warriors, for example, are said to have used shields made from stretched leather. During the Celtic Christian era, the process of curing leather became more refined, and one of its most important uses was in the construction of boats used by the seafaring Celtic monks. These boats consisted of a supple wooden frame around which cured leather was tightly stretched. Tim Severin, author of *The Brendan Voyage*, recreated one of these boats on the west coast of Ireland in the 1970s using identical materials to the original boats of over a thousand years ago. He demonstrated its incredible seaworthiness by sailing it across the Atlantic to the northeast coast of America.

Today, there are a few highly skilled workers in leather, who use techniques by which Celtic designs are embossed onto the material and then coloured with various types of dyes. Some of the applied colours can be produced by using organic materials, such as plants or tree-bark.

It is in a leatherwork studio and workshop in Ullapool, on Scotland's remote and beautiful northwest coast that Sue and Iain Gunn of Celtic Leather produce their beautiful work. 'Creating things' had always been the main preoccupation for Sue and Iain Gunn, who left their 'proper' jobs of teaching and working in graphics, to live in the Peak District of Derbyshire. It was there, while they were running a very small craft shop, that they met a travelling salesman who mentioned a place he'd heard of on the northwest coast of Scotland called Balnakeil. An old early warning army camp was being offered by the council to provide homes and workshops for craftspeople. So the Gunns went and looked – and were hooked. Sited in the most breathtaking mountain and beach scenery, the area was perfect for 'creating', and living a life close to Nature.

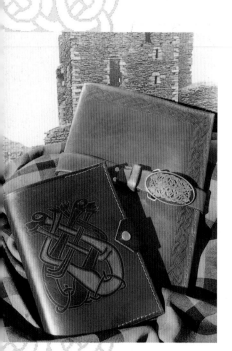

Leather notebook covers by Sue and Iain Gunn of Celtic Leather, Ullapool.

It was there that they first became aware of books on Celtic art and became the proud owners of a full-size facsimile edition of the Book of Kells. This beautiful book was originally scribed by monks on the island of Iona, off Mull in the Inner Hebrides, but as a result of constant Viking raids was later taken to Ireland, ending up in the monastery at Kells, County Meath. The illuminated manuscript, made from pages of vellum (calf-skin), was created to display the perfection of a book dedicated to God. In some highly detailed designs a small area might be left unfinished or a small mistake might be purposely made to indicate man's inferiority to the God. The history of the Book of Kells is first recorded in *The Annals of Ulster*, which

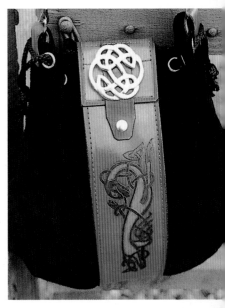

establishes the book's presence in Kells in the early eleventh century. In the year 1006 it is written: 'The great Gospel of Columkille (Columba), the chief relic of the Western world, was wickedly stolen during the night from the western sacristy of the great stone church at Cenannas (Kells) on account of its wrought shrine.' Apparently, it was found a few months later 'under a sod' and minus its ornate wood and gold cover. The ornamentation of the book shows the minute and ingenious interlacings, key patterns, spirals and entwined creatures, which conspire together to create whole pages of carpet-like patterns. The Gospel text is written in 'Irish script' and ornately decorated initials appear on nearly every page. It is believed that a master artist would have designed the patterns and constructed the original layouts of the pages. Other scribes would then have filled in the colours very carefully, using fine brushes made from pine-marten fur. Some of the designs that artists use today in various media were often only ½ inch in size, and included combinations of spirals, knotwork, zoomorphics and key patterns.

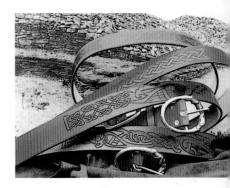

Bag, belts, wallets and hair slides, made by Celtic Leather.

Sue and Iain settled down to life in the most northerly community on the mainland of Britain, originally designing and making soft toys and a range of hessian tableware and hangings, which they screen-printed with Celtic designs. The harshness of the climate and the short tourist season, however, forced them to move, first to

Caithness, and then to Cornwall and Devon, where they found the climate much more appealing. Now working in leather, the Gunns were developing and consolidating their knowledge of Celtic art, which they used to decorate each piece of work. When it was transferred to the hide, the design was engraved with a V-gouge tool and then hand-painted. The first thing that Iain ever made was a beautiful waistcoat with a Celtic dragon/beast on each front. This piece of work is still coveted by friends and customers alike, although nowadays it's a bit on the small size.

From this followed belts, bags, pictures, mirrors and so on, all highly ornate, engraved and painted with designs inspired by the Book of Kells. By this time Iain was able not only to reproduce these designs but to create his own, and to adapt them to the various leather items as required. The painting and dyeing techniques evolved through trial and error, so that now Sue and Iain's leather has a distinctive appearance, of rich, glowing colours shining out of backgrounds of mellow warm brown, tan and mahogany, all with an ancient look.

A holiday in northern Scotland had such an impact on them, and especially their three children, that they eventually returned to live in the Highlands; first at Stromeferry, near the Kyle of Lochalsh,

Mirrors with leather surrounds decorated with Celtic motifs.

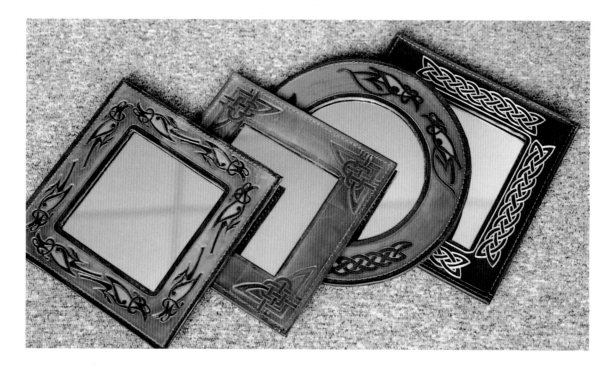

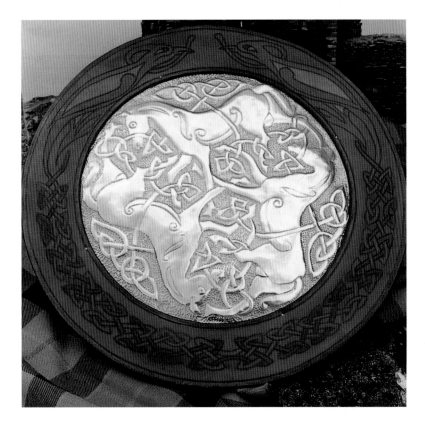

A pewter roundel with an ornamented leather surround, made by Celtic Leather.

where they had a small studio and workshop, then at Ullapool, where they now live and run a successful leather and Celtic crafts gallery, which is open all year. The shop is a perfect showcase for all their work, and the carefully selected quality crafts with a Celtic theme blend with and complement the leather pieces. Visitors are fascinated by the Green Man, who watches them from the wall, hanging next to the Earth Goddess. These are part of a range of on-going large pictures depicting various Celtic deities, including the recently completed leather portrayal of Cernunnos, one of whose aspects was 'lord of the animal kingdom'.

Sue and Iain's work has been widely purchased by customers from Britain, Europe, Japan, America and Australia. Life in Ullapool is hectic, rewarding and exciting, and plans are afoot to open a second shop in Edinburgh, which will be managed by their daughter Sarah. When things get too hectic, Sue and Iain escape for a day back to beautiful Balnakeil, where the original ideas for their successful crafts ventures first began to take shape.

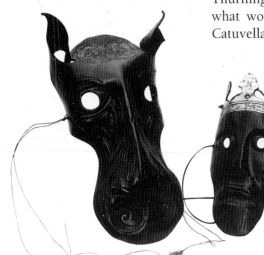

Horse and King masks, made by Epona Craft.

A very different approach to Celtic leatherwork is evident at the workshop of Epona Craft, which is run by Justin Capp at Thurning, near Peterborough. The workshop is on the borders of what would have been the territories of the Coritani and the Catuvellauni tribes in the first century BC; the boundary of the notorious Iceni tribe, presided over by queen Boudicca, is approximately 20 miles to the east. Epona was the revered horse- or mare-goddess of the early Celts, and a number of effigies of her have been excavated, usually riding side-saddle. The cult of Epona is believed to have had its centre in the region of Alesia in eastern France towards the end of the first millennium BC. The cult soon spread to Britain, and even today vestiges of horse-veneration can be found as large hillside carvings cut into chalk soil. One of the finest is the White Horse of Uffington, sited on a hillside next to Uffington Castle Iron Age hillfort in Berkshire. The magical nature of the horse continued in the Celtic countries until at least the fourteenth century, when descriptions can be found associated with Rhiannon in the *Mabinogion* tales. From written accounts by Classical writers, including Julius Caesar, of the Celts' supreme mastery of horsemanship, it seems natural that the cult of Epona was widely accepted throughout pre-Christian Britain and Europe.

Justin Capp began working in decorative leathercraft in 1993 when he visited Dyfed and discovered the work of a craftsperson applying traditional Celtic designs to more modern leather accessories. Suddenly he had a strong vision of how our ancestors might have used a versatile and widely available material, although, sadly, of course, the damp climate means we have no direct examples of any leatherwork from the early Celtic period.

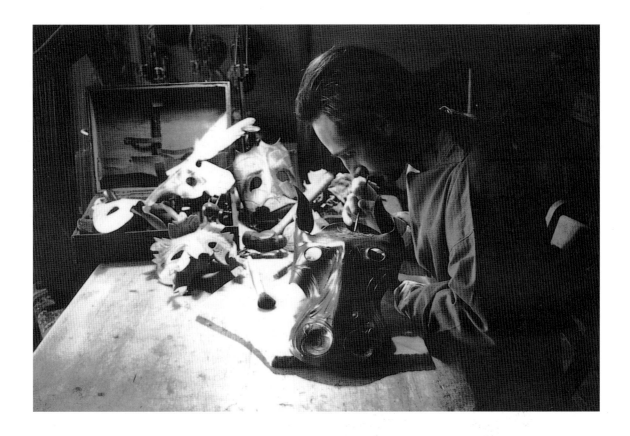

According to Justin, the word 'tan' comes from the Celtic word for a small oak tree. In ancient times skins would have been cured in pits in the ground, and almost all leather would have been treated in this way. To achieve the transformation from skin to leather, the skins are steeped in a solution of water and oak bark for about eighteen months, to complete the tanning process. In order to tool designs, the leather has to be re-soaked, and therefore the only hides that are suitable are those traditionally tanned by this method, because they have a porous quality.

In the process of decorating leather, the re-soaked hide is scored with a blade to the required design. One side of the line is then depressed to achieve a three-dimensional effect. Different patterns and textures can be created by hammering tools or materials onto the surface and thus imprinting a pattern. Anything from specific metal stamps to pieces of hard tree bark can be used to create effects and textures.

Leather may have been used occasionally by the Celts for artwork, but mainly it was used for practical things. There is some strong evidence to suggest that the Celts used stretched leather shields in battle. These would almost certainly have been

Justin Capp of Epona Craft at work on a leather horse mask.

decorated with the characteristic symbols and designs that are familiar to us from Celtic metalwork. Leather was also used for items such as sword scabbards and articles of clothing. It would have had a special significance in the life of the warrior for its mystical/ shamanistic qualities, and the bull was a highly venerated animal, a popular subject throughout all periods of Celtic art and the focus of attention for many Celtic stories and legends.

The great diversity of the animal kingdom gave a wealth of inspiration and knowledge to a civilization more in tune with the workings of Creation. From the beginnings of time animals and birds have provided man with an endless reference for art and storytelling, strengthening the links between humans and the animals, and allowing humans to discover more of the concealed facets of our individual selves. Each of us is drawn towards different animals with which we feel empathy or identify with in some way.

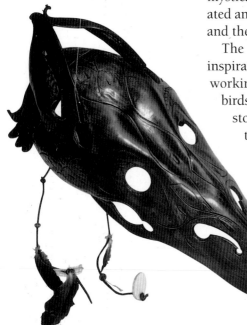

Crow hood mask, made by Epona Craft.

In his work Justin attempts to highlight the declining awareness of animals in our environment and culture. Through making masks he tries to create images of how birds and animals may have been viewed or depicted in Celtic times. He uses both contemporary and ancient designs, focusing on animals we can still see today, as our ancestors did more than 2,000 years ago.

From early times man has used masks to help him understand more about himself and his surroundings.

Justin believes that the mask represents a primal and instinctive desire on the part of humankind to place itself in a collective universe of which humans are but a small element. It is an ancient custom to use masks in a search for a loss of personal identity, a transient appearance that gives the wearer an opportunity to think or feel in a different way. An animal mask, for example, may develop the wearer's conscious awareness of the environment.

Many Celtic deities appeared in the form of birds and animals. Possibly the best known is Cernunnos, often referred to as the Celtic stag-god. There are many examples of the cult of Cernunnos, including his depiction on the famous cauldron found at Gundestrup, and his is also the only written reference of a god's name, found in France carved in stone. The Celtic–Druidic oral tradition and absence of writing make this

carving unique. The stag's branching antlers, which featured in early European Celtic art, symbolized the Tree of Life and were a focus for worship. Crowned with vegetation, the stag represented the union of the animal and vegetation gods of the woodland. The constant shedding of the antlers became a symbol of regeneration and rebirth. From the symbol of the stag evolved the more widely known motif of the Green Man as the spirit of vegetation and nature.

The Celtic war goddess, the Mórrígan, was depicted as the crow, a symbol of violence as well as one of protection for the ancient warriors. The crow's association with the battlefield was the result of the bird's inevitable presence near carrion.

Justin found another source of inspiration in the idea of shape-shifting, as demonstrated in the Taliesin cycle. Ceridwen and Taliesin are transformed into a succession of animals in a struggle in which each species uses its characteristic strengths and abilities to outdo the competitor. This idea of metamorphosis is particularly appropriate to mask making.

In Northamptonshire, which is where Justin lives and works, the traces of our ancestors are hard to see. There are no standing stones or similar monuments nearby, but the history is close here, if hidden. Not far away is the small town of Desborough, where a famous and beautiful decorated Celtic bronze mirror from the first century BC was found. Crop marks in the area have revealed that there were many Iron Age sites of homesteads, but these are not immediately visible. They lie dormant beneath a transformed landscape that is no longer considered by most people to be associated with the Celts.

Leather masks of Cernunnos, and The Green Man, made by Epona Craft.

TEXTILES, FABRIC-PRINTING AND EMBROIDERY

EXTILES ARE PROBABLY the most popular medium for the display of Celtic designs. In the first century BC the Roman historian Diodorus Siculus (Diodorus the Silician) wrote of his encounters with the Celts that they 'wear striking clothing, tunics dyed and embroidered in many colours, and trousers, which they call *bracae*, and they wear striped cloaks fastened by a brooch, thick in winter and light in summer, worked in a many-hued, closely set ornate pattern'. From this contemporary description one can imagine designs of bold La Tène curves and swirls adorning the tunics of these extrovert and artistic peoples.

There are many examples of Celtic designs applied by various methods to textiles, including recently the use of computer programming with sophisticated knitting machines to incorporate Celtic designs into knitwear. Earlier this century, especially in Ireland and Scotland, some fine knitwear was being produced embodying Celtic designs, but the finished items were all completed by hand, using hand-spun wool and traditional knitting methods.

Today, screen-printed Celtic designs are often seen on T-shirts, and in the last few years this fashion has spread throughout the world, being especially popular in the United States. The designs employed and the techniques used range from the mediocre to the very fine. Some T-shirts are hand screen-printed in small rural workshops by craftworkers using their own

A T-shirt with a Celtic design by David James, produced in a crafts workshop in Virginia, USA.

original designs. Other designs are taken directly from early sources and mass-produced using such modern techniques as full-colour laser printing. Many people regard these latter methods as rather sterile and devoid of creativity.

David James was producing his own original designs in the late 1970s and early 1980s, and these were screen-printed by hand onto cotton shirts by a crafts enterprise in Virginia, USA. At the time, over fifteen years ago, there were few workshops producing Celtic clothing. Today, Celtic designs are being printed by various methods onto textiles to produce items such as bedspreads, tablecloths and large wall hangings, as well as fine hand-printed silk items such as scarves, ties and waistcoats. One business producing fine hand-printed Celtic and also Pictish designs on silk is Stoneline Designs in Edinburgh, which is run by the artist Marianna Lines. Welsh-born Jen Delyth who now works in San Francisco, California, also produces fine designs on silk, including silk screen-printed scarves.

Embroidery has also seen a strong upsurge in the last ten years, and several excellent pattern-books of Celtic designs are available. Embroidery is relaxing and therapeutic, and it is ideal for anyone who can spend a short time each day on a creative project, which eventually will look very striking. Time is unimportant to the creative person who undertakes a piece of embroidery for his or her own pleasure and who works on the piece as and when the mood takes.

Larger embroidery projects can be undertaken by the more ambitious. David James was commissioned in 1985 to produce an original Celtic cross design to be used on the back of a priest's robe. The design was painstakingly hand-stitched in gold thread by a stitcher in Northumbria, who took over a year of daily work to produce the finished product, which is regularly used by a priest in Ireland today.

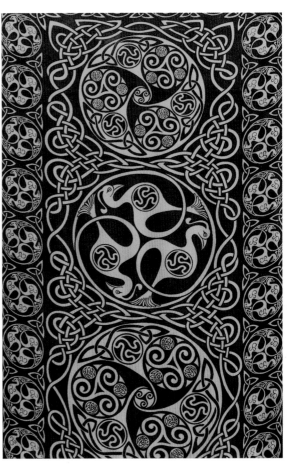

A silk scarf designed and printed by Jen Delyth in San Francisco.

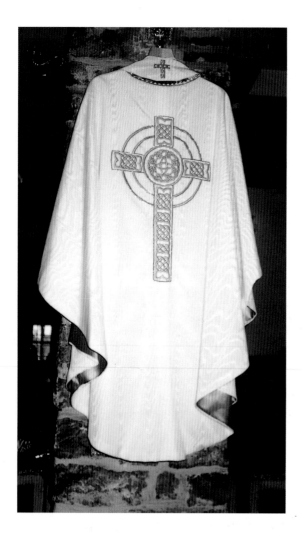

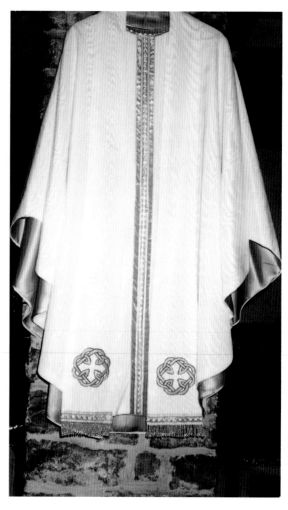

Hand-embroidered priest's robe in gold thread; original design by David James.

One of the most spectacular and unusual textile works was created on the Holy Isle of Lindisfarne, off the coast of Northumbria. In the small twelfth-century church on the island there can be found the most remarkable carpet. Measuring 9 feet 3 inches by 11 feet 6 inches, it is an exact replica of the cross-carpet page that introduces the Gospel of St Mark, in the Lindisfarne Gospels of the late seventh century. It incorporates the most intricate knotwork designs, step-patterning, spirals and bird and beast patterns. The carpet was designed and its production directed by Kathleen Parbury, who also designed and made the statue of St Aidan next to Lindisfarne Priory. The students of

Alnwick College translated the design onto canvas, and the actual needlework was done by eighteen Lindisfarne Island women, who took over two years to complete the masterpiece, working at a density of approximately fifty stitches per square inch. The exact carpet pattern can be seen in Janet Backhouse's *The Lindisfarne Gospels*, and this picture shows just why the finished carpet is unique and a fine example of island community collaboration. The carpet (below) was dedicated in St Mary's Church in June 1970. Since then the carpet has inspired Kathleen Parbury and the skilled islanders to design a second one with a different Celtic pattern, which at the time of writing is in the process of being made. This one will grace the Fisherman's Altar in Lindisfarne's church.

The carpet in St Mary's Church, Isle of Lindisfarne. The design is taken from the introductory page to St Mark's Gospel in the late seventh-century Lindisfarne Gospels.

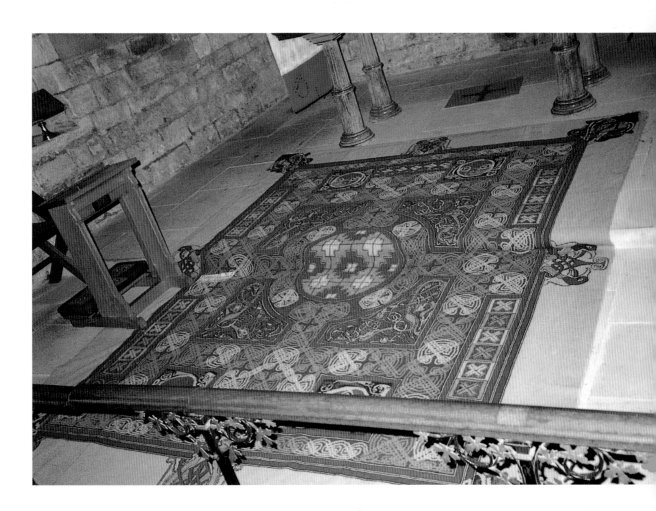

PYROGRAPHY

P YROGRAPHY IS THE modern name for the craft of burning designs onto wood. Before the invention of electricity it was practised under the name of pokerwork, the designs being applied to the wood using a sharpened metal poker, which had been heated in the open fire. The craft is centuries old, and fine examples, including decorated fire-screens, cottage stools, wooden bowls and platters, can still occasionally be found. Today the craft has become more sophisticated, and an electric pyrography iron has replaced the fire-heated poker. These pyrography irons have metal tips with a wide variety of thicknesses, which are capable of producing designs ranging from those with a reasonably broad outline to lines of the utmost delicacy. An electric coil surrounding the metal tip keeps it at a constant temperature, providing ease and flexibility for producing very elaborate and complex patterns.

This section on pyrography describes the work of David James and his initial involvement with Celtic arts and crafts. In 1976 David moved to a dilapidated Scottish farmhouse in the hills of Kintyre, Argyll, from where, on a bright day, the coast of Northern Ireland was clearly visible. Just over the hill to the north were spectacular views of the isles of Islay and Jura. Although he had read about Jura and its association with 'goddess figures in the landscape', much of what he had read seemed rather far-fetched until he saw the silhouette of Jura and tried to imagine the thoughts of our ancestors as they surveyed this view. Of this view, David says: 'The two main mountains on Jura are aptly named the Paps of Jura, and if you look at the silhouette of the island and let your imagination roam freely, you can see the shape of a sleeping female figure, her hair trailing to the right of the picture. Moving to the left you see the point of her nose, then her two breasts, a rounded pregnant belly, and her legs stretching out to the left.'

David James working on a clock face in his pyrography studio in Dorset.

This landscape figure had been pointed out in several books, and it was all the more interesting when, in 1995, the BBC television archaeology programme *Time Team* undertook a dig at Finlaggan on the neighbouring island of Islay, expecting to discover medieval remains associated with the Lords of the Isles. To their surprise, they discovered a hitherto unknown Stone Age alignment, which led directly to the Paps of Jura, an indication of their special significance several millennia ago. Since that time David has encountered other goddess figures in the natural landscape – for example in Cornwall and on the Isle of Lewis in the Hebrides – although Jura remains the most spectacular example.

The area surrounding David's farmhouse was scattered with Celtic, Bronze Age and Megalithic remains, and proved an ideal environment for him to start enquiring into the nature of Celtic designs. It was at this point that he came across George Bain's book on the methods of creating Celtic designs and also saw a facsimile of the Book of Kells, one of the most beautiful books he had ever seen. He soon started to create his own Celtic designs, simple ones at first and then more complex and ambitious drawings as his confidence increased.

At the time David was a potter, and he applied some Celtic designs to large plates, using the sgraffito technique of carving

View of the Isle of Jura from just north of David James' farmhouse on Kintyre.

107

through a layer of white slip into the darker clay beneath. These plates proved very successful, but the amount of time involved in producing them didn't make them cost-effective. By this time Celtic art had really taken a hold of David, and he wanted to experiment with applying it to different media. He also had the opportunity to write a book, partially funded by the Highlands and Islands Development Board, which was called *The Carved Stones of Western Scotland* and was published on the Isle of Lewis in the Outer Hebrides in 1978.

In 1980 David moved from Scotland to the west of England, to a cottage about one mile from Eggardon Iron Age hillfort in west Dorset. Although the climate in the south is much gentler, he, like many other people, found that he hankered after the mountains, wildness and wide open space of the west coast of Scotland. However, Dorset has proved a congenial place to continue with his Celtic work, and he soon started some new projects, including designs for silver jewellery and experimenting with stained glass.

During a winter spent in a cottage owned by the late Reynolds Stone, a well-known and reclusive boxwood engraver and designer, whose work included some high-denomination British postage stamps, David first experimented with wood, when he was given a quantity of sizeable off-cuts of high-quality, seasoned oak. Having considered possible domestic uses and found the wood inappropriate for some reason or other, he decided to try carving some Celtic designs onto the already smooth surfaces. He spent the entire winter producing small detailed Celtic carvings, most of which were sold before they were finished because they took a considerable time to execute. Seasoned oak is very hard, and during that winter he broke two chisels as well as completely wearing out a sharpening stone. Several of the designs were of Celtic crosses, and one was a commission for a meditation sanctuary in Stroud, Gloucestershire.

The following year, David met an old friend, John Buckland, who now runs a highly successful woodturning business, Creamore Mill Woodturnery, in Wem, near Shrewsbury. At the time of their meeting John was producing beautiful hand-turned bowls and platters. On seeing David's woodcarvings, he asked if he had encountered pyrography; the result of their meeting was that John began to supply David with beautiful turned limewood and sycamore bowls and platters. David bought a pyrography iron with a selection of tips and embarked on pyrography, which he found to be an ideal way of transferring complex designs onto

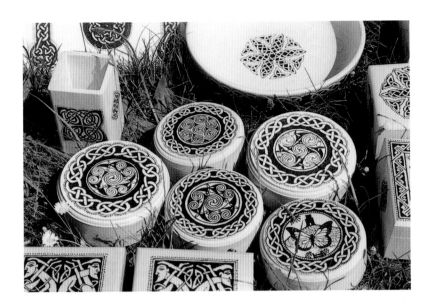

Some examples of pyrography items that incorporate Celtic designs.

wood. As well as bowls and platters, he decorated limewood and sycamore boxes and plain sycamore clock faces. The process of decoration involves making photocopies of the designs, and then tracing the outlines through carbon paper so that the imprint is left on the virgin wood. This is then burned over with the pyro-

Limewood and sycamore lidded bones with Celtic motifs in pyrography.

graphy iron, and the finished product is coated with Scandinavian oil. The scorched wood is aromatic and adds an interesting fragrance to the workshop. On larger, complex Celtic designs, which can take hours of patient work, it is necessary not to let your mind wander, even briefly, otherwise a hot pyrography iron can burn a hole in whatever you're wearing.

David continued to use pyrography to apply Celtic designs to various items of woodwork and steadily built up a small business, supplying finished items to shops in Britain. Some of his work were also exported to Brittany, where they sold well.

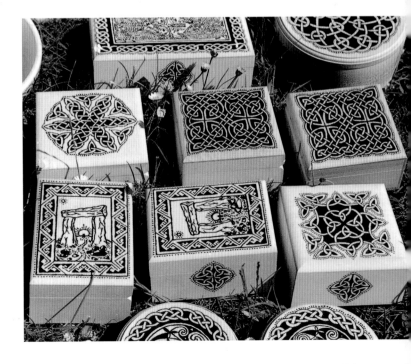

BEADWORK

MONG THE VARIOUS adornments worn by the Celts were beads. Examples dating from the earliest times have been found throughout Europe, Britain and Ireland. Some of the finest of these have been unearthed in burial mounds and chambers constructed for high-ranking Celtic chiefs and their followers. These beads vary from the plain to the highly decorated, and they have been found made from gold, silver, electrum, stone, black jet, bone, amber and, occasionally, semi-precious stones. It is quite possible that the Celts were influenced in the making of beads by the ancient Egyptians, who were highly skilled at bead-making and used lapis lazuli, carnelian and jade in their highly polished necklaces.

Today carved Celtic beads are being ingeniously created in South Wales by Annie Wealleans, alias The Black Dragon of Black Dragon Crafts, in her workshop in Pencader, Dyfed.

Annie and her husband moved to Wales in 1974 in search of that elusive rural idyll. For a year they made leathergoods and candles in a spartan barn on a hillside near Machynlleth, and then they moved south 50 miles to the softer landscapes of Carmarthenshire, where they found a stone shack, which was reached by a cart track. There were no neighbours within yelling distance, and the shack stood in a one-acre paddock. The potential of the place was huge but there was no electricity, no water supply and no telephone. Instead, there were bats, spiders and woodworms.

They spent the next few years working on the house, and whatever time was left from mixing cement, tending the field they had transformed into a lush green larder, shepherding sheep or chasing assorted ducks, chickens and geese, they were still busy with leather and candles. As wax prices rocketed in the days of the oil crises, they produced an ever-increasing range of hand-tooled and carved leathergoods, a craft Annie learned on a trip to

California. She made bags, belts, keyfobs, clocks, mirrors, wristbands and boxes – all of which were painstakingly assembled by her husband. Annie decorated them with flowers, patterns and landscapes and sold them at craft markets and to gift shops.

As word of what they were doing spread, the orders and commissions rolled in, and the candle making stopped. One day, an enquiry came for a bag made with a stylized badger's paw print carved on the flap, and a Celtic knot within each paw pad. Annie began researching the art form and became utterly fascinated by it, poring over books for hours and doing endless drawings. She loved the way the knots laced and entwined in unending perfection. The bag was a masterpiece, and the customer was delighted.

That Christmas, George Bain's book was in Annie's stocking, and she began to carve Celtic designs into the leather. They had to be simple knots, for the work was popularly priced and the public seemed greedy for them. Eventually, she had some tools specially made, so that she could emboss the knots into the leather using a fly press. Production increased to justify the tooling costs, and Annie became more ambitious with the designs. The possibilities, like the knots, were endless.

Annie says that there seem to be Celtic knots everywhere in her life: 'I met with many other craftspeople here in Wales who worked with knots. They burned them into wood, carved them on slate, painted them on silk, printed them on paper, leaded them into windows, worked them into pewter and cast them in metal…. Their designs were faithful reproductions from known original sources; mine were merely satisfying patterns, used to good practical effect. I felt woefully inadequate but sales of my work were proof of my success – how else should I measure it?'

Annie Wealleans at work in her Celtic bead workshop in Pencader, Dyfed, west Wales.

Annie took to visiting the ancient sites and immersing herself in the history of the area, finding that there was much to learn from the days of the old ways. The family lived close to the land, so it was easy to imagine the life of the ancient Celts. Annie recalls: 'We marvelled at stone circles, grieved on burial mounds, clambered over castle walls and sought out interesting headstones in graveyards.' She finds special inspiration in the little church at St

Ishmael's; in the churchyard is an extremely fine example of a contemporary Celtic cross, with highly detailed carving.

In the late 1970s Annie's family travelled to Greece and Turkey, partly with the intention of visiting the ancient Mediterranean sites. On their way home, they stopped in Istanbul, and the jewellery they saw in the market there made them aware of new commercial possibilities. They spent their last coins on a collection of metal and glass artefacts, and when they were home again, they stripped them down to their component parts and reconstructed their own versions of them.

Before long, they were producing not only leatherwork but beaded jewellery as well. Annie became increasingly obsessed with developing her own creative skills, and, she says: 'I clothed myself in a new identity and became the Black Dragon herself. I took myself to India in search of components, treats and treasures, and revamped the local market stall from which we had been trading for many years.' She went on a craft design course at Lampeter University and immersed herself in the directorship of Origin Dyfed, a local community crafts co-operative. At a trade fair she was asked why she didn't use Celtic beads in her jewellery. This would have complemented the Celtic leathergoods and seemed to be a good idea. She searched through all the bead catalogues she could find – not only in the UK but further afield as well – but found absolutely nothing. Eventually Annie decided to see if she could make them herself. It would be an interesting challenge, and she set about investigating the possibilities.

She spent many hours on the telephone, learning about the different materials from which beads could be made. She picked brains from all over the UK, wrote many letters and did dozens of sketches. The concept began to take a physical form, and she decided that man-made materials were the most appropriate for the project. She knew nothing of production techniques, having spent her entire working life with natural materials, but, as she says, it is remarkable how quickly one learns.

Eventually, she met Bob, a sculptor from mid-Wales, who thought the whole idea was perfectly feasible. The first 'bead' to come back looked more like a copper bobble on a stalk than a bead, but Annie sent it off to be replicated 5,000 times in plastic and then 'metallized'. When these beads were delivered, Annie remembers how she felt: 'Pleased, proud, overjoyed, relieved, euphoric. Looking back on it, I shouldn't have been. They weren't

good enough but I had proved something. Celtic beads were possible: the journey had begun.'

Annie decided special packaging would be a good idea because she wanted everyone to know that this was a special product. She had a recycled, black, knotty, Celtic-bordered card in mind and a

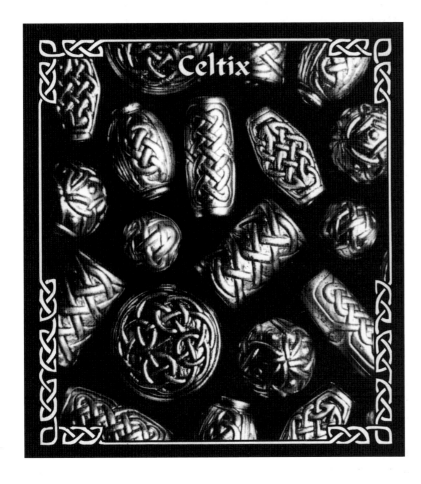

Some examples of carved Celtic beads made by Annie Wealleans.

friend improved on her design and organized the printing. They sent out samples to selected customers and waited. The response was good, and, thus encouraged, she set about raising the money to do the whole thing properly. She met a representative of the economic development unit of the local council, and he thought it was a wonderful idea and recommended funding the project at the next council meeting. Annie's enthusiasm must have been

contagious, for they readily agreed to fund her if she promised to create a job and protect the designs. Thus Celtix was born.

Fine contemporary Celtic cross at St Ishmael's overlooking Carmarthen Bay, Wales

She was put in touch with a local specialist injection-moulding business, and together they worked out which bead shapes might be practicable within the constraints of the manufacturing process. She went back to Bob, the sculptor who had made the first prototype, and they settled on a larger sphere and a cylinder. These proved to be ambitious choices, because the bead moulds had to be made in two halves and the join would have to be hidden, without interfering with either the central hole or the Celtic knotwork. The company experimented with different moulding materials and began work on the tooling; Bob hand carved the 'originals' from which the moulds would be made; and Annie began to search for a company with the capacity to plate many thousands of tiny plastic objects with real sterling silver – she was not going to settle for anything less.

During this time, Annie kept coming across beautiful pieces of silver and gold Celtic jewellery, made with exquisite workmanship and wonderful designs. Each time she had to walk away. Part of the ethos behind Celtix was that the beads had to be affordable. Annie wanted to design a collection of beads with which she could produce a range of jewellery that was within everyone's reach. She had always thought it unfair that beautiful things should be the prerogative of the privileged, and she regarded Celtic designs as a part of our heritage, culture and tradition, and believed that they should be within the limits of all of everyone's purses.

The summer and autumn of 1993 were hectic. Celtix was off the drawing board, moulded in partly recycled ABS material, plated with a generous layer of genuine sterling silver and finished with an antiquing lacquer to accentuate the Celtic knotwork. Annie had decided that, come what may, she was going to launch Celtix officially at the Wales Fair, to be held in October. By national standards, this is not a huge fair, but it is the biggest trade fair in Wales, and she had been exhibiting there since 1974, when she first joined the Wales Craft Council. She had the design written prototypes of three Celtix beads, good literature, attractive packaging, competitive but realistic pricing – in all, Annie felt that she had achieved her goal and managed to produce something totally original. And she was very proud of it.

In fact, Celtix won the Best New Product Award at the show. The orders began to arrive and confidence grew. Annie started to advertise Celtix and found that there were other craftspeople who wanted to work with Celtic beads. The products they were making were selling well, and Celtix began to expand the range of items available. They made earrings, strung them on leather, cord and chain as necklaces and bracelets, and combined them with coloured ceramic beads, metal spacers and, increasingly, semi-precious gemstones.

As word spread, the ideas grew. Why stop at three Celtix bead designs? Annie not only designed another two beads, but also improved the first one she had made. The whole process seemed to take forever but they were worth waiting for. Now she has a total of seven Celtix beads and they are moulded in batches of 80,000 – a far cry from the stalky bobble! Now Annie sells Celtix in Africa, Spain, Japan, USA, Ireland, France, Germany and Canada, not to mention England, Scotland and Wales and many points in between.

STAINED GLASS

STAINED GLASS IS another medium well suited not only to Celtic designs but also, because of the interplay of colour and light, to the atmosphere of some of the remote and beautiful Celtic landscapes.

The making of glass was known in Roman times, and even earlier European Celts created small areas of coloured glass fused onto bronze artefacts in a method similar to enamelling. Some items of La Tène-style jewellery were decorated in this way. It was not until early medieval times, however, that flat pieces of coloured glass were combined in grooved lead cames to form beautiful coloured windows. The most magnificent early examples of these are the stunningly beautiful rose windows found in cathedrals throughout western Europe. The finest of these, and some of the earliest, are probably those in Chartres Cathedral, France. Some say that it has not been possible to reproduce the colour of these particular rose windows, and certainly these windows are, for many people, some of the finest craftwork of the early medieval era to be found anywhere. Similar massive rose windows of an early date can be found in Notre-Dame Cathedral in Paris. Seeing the sunlight shining through these windows and projecting the colours onto the interior stonework is an unforgettable experience.

During the Victorian era and the early part of this century a number of fine stained glass windows were created in churches and chapels throughout the Celtic countries and in other locations associated with particular Celtic saints. There is, for example, a fine depiction of Joseph of Arimathea in St John's Church, Glastonbury, and in St Non's tiny chapel on the coast of southwest Wales five Celtic saints are portrayed in beautiful stained glass windows, which were constructed in the early 1930s.

A large four-panelled stained-glass window depicting the seasons on Orkney, made in the late 1980s on the Orkney Isles by Linda Todd of Gaia Stained Glass.

A few examples of fine recent work can be found in all the Celtic countries in both sacred and secular settings. A magnificent four-panel window, made on the Orkney Isles in the 1980s by Linda Todd of Gaia Stained Glass, depicts in colour and design the four seasons as experienced on these remote and beautiful islands (see illustration above).

Gary Smith, who has a workshop in South Queensferry, Scotland, feels that glass is a magical substance: 'Formed from

Opposite: *St Brynach standing in front of the tenth-century Nevern Cross. This stained-glass window was made in the 1930s for St Non's Chapel in Dyfed, Wales.*

crystals of quartz sand, transmuted by fire in a furnace. Or whirling through space, great globs are formed by the intense heat generated through entering the earth's atmosphere. A super-cooled liquid, coloured by base metals and oxides, formed into flat sheets and cooled gradually to harden.' In addition to glass, the stained glass artist needs lead cames, lead and tin solder and linseed oil putty. The tools used – a glass cutter, a pair of pliers and a soldering iron – have remained virtually unchanged since early medieval times. The craft of stained glass has defied mechanization, and is still carried out by hand.

Gary set up his studio in South Queensferry, just outside Edinburgh, in 1987. There is, he says, a great sense of light and

Leaded stained-glass window with Celtic knotwork and an ivy-leaf border, by Gary Smith of Celestial Stained Glass.

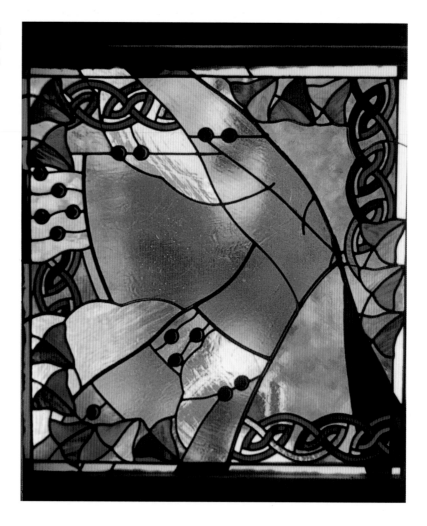

sky and water from where he works, as well as the dramatic changes of weather that occur. He finds that this provides inspiration for his work, and he also thinks about the remote Holy Island of Iona to the northwest, a burial place of ancient Scottish kings, where Celtic and Druid mysteries weave with the strands of early Christianity, and a place described by the Reverend George Macleod, founder of the Iona Christian Community, as: 'A place where only a thin veil separates the material from the spiritual realm.' Also in Gary's thoughts as he works are the Outer Hebrides – 'wild remote islands full of ancient spiritual sites and a tradition of craftsmanship still alive today' – the Highlands – 'a wilderness of great beauty, where eagles soar high above and salmon leap in rivers and lochs' – and the hills of the ancient kingdom of Fife, sometimes snow-capped, which are visible from his studio.

Over the years Gary has worked on many commissions for windows, door panels, lamps, mirrors and window hangings. He has also set up a craft and design shop to sell both his own work and a wide range of other high-quality crafts, and this has been a congenial setting for prospective clients to begin thinking about commissions.

The process begins with an initial talk, either in the studio or in the client's home or business, where they will discuss a range of ideas and Gary will show a portfolio of his previous work together with books of inspirational work past and present, including Celtic designs. Once the seed of an idea has been agreed upon, Gary works on a finished design to scale, which he shows to the client for approval. Once the client has approved the design, work will begin on drawing the design at full size, having, of course, first taken accurate measurements of the space the window will fit.

From the original full-size cartoon, Gary makes a tracing showing all the lines that separate each piece of glass. This is called the cutline and will be used to cut the glass accurately and to lead the whole window together on the bench.

The glass cutting is a vital part of the creative process. Gary selects glass for its colour, tone and texture, and at this stage changes can still be made – some glass will be rejected, and other pieces included. After leading the cut shapes together and soldering the joints on both sides, putty is pushed between the glass and the flanges of the lead to strengthen the panel and make it weathertight. A large window will have to be made in several

sections about 2 feet by 2 feet, joined together and supported using metal glazing bars and copper wire ties.

A commission can take anything from a few days to several months to complete, and the price will vary according to the complexity of the design and the materials used. Celtic themes have featured very strongly in Gary's work in the form of crosses, borders of interlace or as depictions of ancient stonecarvings.

Gary runs weekend courses when people can learn about the craft and can even take home with them a piece of their own work. In 1992 he began working as a part-time sessional artist at the Edinburgh Aids Hospice, where he has been helping to create a community window on the theme of the Tree of Life. Images, poetry, real flowers and leaves, agate, gemstones and sand-washed glass from the beach have all found their way into the window, and many people have worked on it, and it continues to grow and express the diversity of life through different styles and ways of working.

Gary has also started other, similar projects with different groups of people, involving everyone at all stages of the work. Gradually, community arts sessions have become the main focus of his work, and he travels around the Edinburgh and Lothian area with a full kit of stained glass tools in the back of his car, working with a different group of people every day. So far he has worked with people with learning difficulties, at a mental health day centre, in a prison and in a community centre. Wherever he goes he finds that there is always a creative focus, placing the work alongside people's individual needs, allowing inspiration to flourish and the group's skills pooled to create a shared piece of work. Many beautiful windows are gradually emerging from the different groups with which Gary works. Celtic themes often find their way into these works, too, either as images of ancient carved stone designs, evoking a distant and ancient discovery of past craftspeople, or by the use of knotwork panels as a main feature. Glass lends itself perfectly to the interweaving patterns of knot-work, and the beautiful glowing colours are brought to life with natural light, which gives added power to the flowing lines. Gary says that he tries to maintain a balance in his life and work between creativity and social interaction, the need for the personal and private, and the wider need to be part of a community that is striving for harmony and a re-connection with nature. The ancient Celtic people understood this interaction, and Gary

has been inspired by the art and craftwork that comes from this tradition, whether it is the faded and weather-worn stones in wild, lonely places or the glowing colours of illuminated manuscripts, the skill of fine interlace work or a simple image of a bird or animal – in all these Gary sees the clarity of spirit and love of beauty that is at the heart of a true faith.

A few years ago Gary developed a range of Celtic panels that he could supply wholesale to other shops. Before the first trade show he attended at Aviemore, he was frantically building a large display stand with a built-in light screen right up to the moment he left to set up the show. It turned out to be a great success, and the work has been much appreciated. He has supplied shops from the north of Scotland to the southern tip of Cornwall, and many of his creations have also found their way to Canada, America and France. The panels are very simple designs, made with traditional lead cames and in a wide range of colours. Gary has built a kiln and has started to experiment with fusing glass, which he finds an exciting process. The gas torch roars away and the temperature gradually rises until the glass softens and melts together. Much experimentation is needed to make sure that different types of glass are compatible with each other, otherwise the work will shatter when it cools. Sometimes, when this happens, the results are extremely beautiful, and Gary puts them back together again as sculptural fragments, suspended within twisted copper wire. In this way, rather than staying with a known formula, Gary continues to explore the medium's potential and to change and develop the work he does over the years, pushing at the boundaries of the possible to see what happens.

Glass will, Gary says, always fascinate him because it defies permanency. Its nature and effect on the viewer is always changing as the quality of light changes. The colours soften in more subdued light, where blues and greens are more prominent, but in strong sunlight, reds and yellows leap out and cast wonderful pools of shimmering reflections on floors or walls. There is a living quality to glass, a radiant spirit that will shine through the work, to uplift and transform the mood of the viewer.

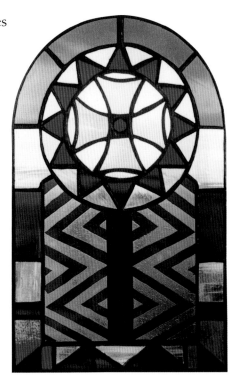

A leaded stained-glass window with a central equi-armed Celtic cross design made by Gary Smith.

GLASS ENGRAVING

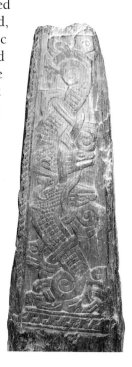

LASS LENDS ITSELF extremely well to the art of engraving; it is a specialist craft, and someone who enthusiastically incorporates traditional Celtic and also Viking art forms in her fine work is Lynn Berry, who works in a home studio in Ramsey on the Isle of Man.

Lynn describes the Isle of Man as an independent island nation, almost equidistant from the coasts of southern Scotland, northwest England and northeast Ireland. From the sixth century onwards the island was strongly influenced by incoming Celtic monks from Ireland, who left their mark in the form of Celtic stone carvings. A little over a thousand years ago the island was colonized by the Vikings, who became rulers of Man, but the bulk of the population remained Celtic, and the island's history and heritage is very different from that of the mainland or Ireland. The Manx people are more Celt than Viking, and Celtic influences are very strong, especially in the ancient art forms found on the island, as can be seen in the large number of carved stone crosses that have been found and are preserved in the local parish churches. These are usually of Manx slate, carved in low relief in the form of a Celtic cross. They are covered in designs that take many forms – human, animal, mythological and abstract – and these

Thorleiff Hnalekis Cross at Old Kirk Braddan on the Isle of Man. This carving was influenced by the Vikings and dates from the tenth to eleventh centuries.

are mainly Celtic in origin and format, although most of them were carved by or for Vikings and also incorporate Norse designs and patterns, such as the familiar interlocking 'ring-chain'. They were used as grave markers or to commemorate special events.

The Manx people are very proud of their island and its unique history and heritage. This includes the Manx language, which enables the islanders to identify closely with the rest of the Celtic world. It is a combination of Old Norse and Gaelic, and has strong similarities with the Irish language. The Manx language is taught in schools here alongside English, and road names, government department names and addresses, government vehicles, and many businesses display their names in both Manx and English.

The Manx people are, in general, very appreciative of arts and crafts, and there are many craft centres, shops and craft fairs on the island distributing a wide range of craft products, such as textiles, wood, jewellery, pottery, graphics and, in Lynn's case, engraved glassware. Music, song and dance also play a large part in island life. Events such as the Manx Music Festival, also known as The Guild, and the International Celtic Festival, Yn Chruinnaght, are attended by enthusiasts from all parts of the world. All of this is a reflection of the importance of Manx culture, and the Isle of Man's place at the centre of the Celtic world.

Lynn started engraving glass in the mid-1980s, after visiting a craft fair in London. She discovered an establishment that sold engraving starter-kits, and she began by engraving everyday objects such as animals and flowers on pieces for herself. As she became more proficient she started to engrave glasses for friends and family. In 1990, soon after moving to the Isle of Man, she moved on to Manx themes, starting with the Three Legs, and successfully developing several versions. She then started to work on local wildlife, engraving animals such as the Loghtan Sheep, which is the four-horned native breed. The name, which means 'mouse brown', reflects the colour of the fleece. She also engraved her own versions of the Manx tail-less cat, of the Laxey Wheel, which is the world's largest waterwheel, and of the Isle of Man TT motorcycle races. Because she wanted to do something really different she began to research into the island's heritage at the Manx Museum, and she found a rich source of inspiration in the Manx carved stone crosses. This is the kind of work she now specializes in and is what she is best known for.

Lynn Berry at work engraving a wine glass in her studio in Ramsey on the Isle of Man.

A friend who taught art at one of the Manx craft centres suggested that she should sell her work, and he agreed to display some in the craft centre's showroom. She started selling her work and giving demonstrations at the various craft fairs around the island. This gradually built up, and now her work is now on sale in three craft centres, two craft shops and two gift shops on the island. She continues to attend craft fairs and has a growing list of commissions. In this short time, she has become well known not only for being the only glass engraver on the Isle of Man who works entirely by hand, but also for being the only the engraver offering true Manx themes, Viking and Celtic designs on glass.

Lynn does not have a shop, which helps to keep her overheads low – like many of the craft workers on the island, she works from home. Much of her work is done is on a commission basis, with customers asking for additional items or recommending other clients. People placing commissions usually look through a book of over 350 designs, which are being added to all the time, before making a choice.

Manx people all around the world are very proud of their origins, and they treasure any item that is truly Manx and reminds them of their heritage. This is particularly true on Tynwald Day, the Manx national festival held on 5 July, when many emigrants or descendants of emigrants visit the home land. These people, known as 'home comers', look for souvenirs to take

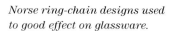
Norse ring-chain designs used to good effect on glassware.

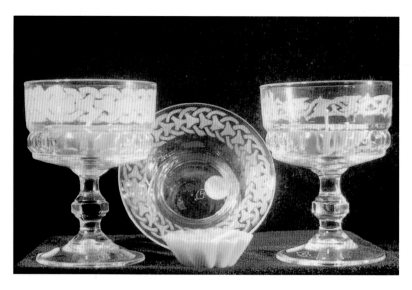

back with them, and through them examples of Lynn's work have travelled to many parts of the world, and this, in turn, has resulted in more commissions.

Lynn makes full use of the Celtic and Norse influences she sees around her, from the Manx carved stone crosses that are preserved in the various parish churches to examples of archaeological finds in the museum, such as jewellery, pottery, coins, carved wooden items, including parts of Viking funeral ships, and even the thirteenth-century Manx Sword of State.

The drawing in Figure 1 shows both sides of the Thor Cross from Bride in the north of the island. It is crowded with figures of all kinds – men, giants, birds, animals, dragons – as well as panels of interlacing designs, all separated by typical ring-chain patterns. These ring-chain patterns became such a favourite with the Norse carvers that they are met at least eighteen times on various crosses and can, therefore, be considered a characteristic of Manx art of the period. From this basic idea other interlacing designs were developed, culminating in the graceful 'tendril' pattern seen on the later crosses.

Lynn regards each of these small sections of the original carving as designs in their own right, and repeating an idea several times or by linking two different designs together, she develops further finished designs. In the same way, a ring-chain pattern in the shape of a circle can be put around a separate design, such as the Three Legs or Laxey Wheel, to create a new design.

The Thor Cross is very detailed and complicated and is not, therefore, suitable for using in its entirety as a design on glass, but Lynn uses the complete design of some of the simpler crosses – for example, the eleventh-century Gaut Cross from Kirk Michael, which is arguably the most famous of the Manx crosses, and forms a beautiful engraving, especially on the coloured glass.

Figure 2 shows two different designs derived from the Thorlief Hnakki Cross in Old Kirk Braddan. These 'units' can be used to form other designs, such as Figure 3, where one of them has been

Figure 1

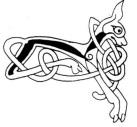

Figure 2

Figure 3

used four times to create a large initial O. In Figure 4 the same idea has been used to make a panel within which a name can be engraved.

Figure 4

In using this method of developing new designs Lynn is really following in the footsteps of the Celtic and Viking artists of long ago, and this makes her work popular with both local and visiting lovers of Celtic and Viking art, especially the 'home comers'.

There are many methods used to engrave glass – for example, a diamond wheel cutter, used in a hand-held motor; acid etch and sand blast – which give different end results. These are all relatively quick methods, but they do not permit fine details in the design.

Lynn uses a totally different method: hand-held holders, which are the same size, weight and shape as a propelling pencil but with diamond or carborundum needlepoints. She sketches the design onto the surface of the glass just as if she were sketching on paper with pencil or pen and ink. This method is very similar to that used in the eighteenth century, when glass engraving was first introduced, and it suits her type of work perfectly, because it enables her to achieve fine detail that is not possible with any other method. The stages involved are as follows.

✠ The design is sketched out on paper in pen and ink. This is when decisions are made about how much detail can be included and how much of the design can be filled in. Remember that what looks right on paper may not be correct for glass – for example, if it is too open, the design will not be bold enough to stand out, or if too filled in, it could result in a blur, with the design looking a mess. Lynn's original design of the Laxey Wheel was too detailed and had to be refined six times before she was happy to use the final result. Each design is tried out on glass as well as paper.

✠ Next, the correct shape and size of glass is selected to suit the design or a suitable design is selected to go with the glassware. A round design, for example, would enhance a brandy glass

but would look out of place on a tall vase. The method Lynn uses allows her to work on almost any item made of glass. If it is very thin or without a rim, it is virtually certain that the induced stress will cause the glass to break, and for this reason Lynn will only engrave glassware that she has personally selected and purchased.

✠ The glass is then polished to remove dust and greasy finger-marks, as the diamond point tends to slip on a greasy glass and not give a clean, distinct cut.

✠ The first stage in transferring the design to the glass is achieved by sketching the outline, using a small diamond point.

✠ Some areas are filled in to emphasize the design and add bold-ness. This is done by using a large or long diamond point on its side, in one direction only. This leaves a shaded or hatched effect.

✠ These areas are worked on again, using the side rather than the tip of a carborundum point to smooth out the shading, and give a clean cut finish.

✠ The remaining outline is reworked using a hard tungsten point. This is to cut deeply and emphasize it.

✠ Repolishing the finished glass removes any dust created from glass or carborundum left by the engraving process. The glass is now ready for display or use.

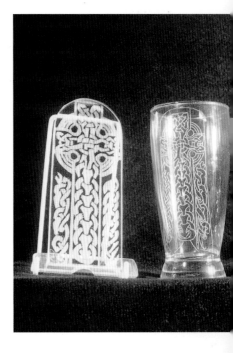

A glass panel and a drinking glass with the eleventh-century Manx Gaut Cross used as the design.

HAND-PAINTED GLASS

NE FASCINATING WAY of transferring Celtic designs onto craft-work is by painting them on glass. This particular craft saw a revival in Victorian times, when mainly naturalistic themes were painted onto items such as mirrors, small window-panels and glass ornaments. Liz and John Cawkwell, who run Celtic Designs on Glass in Llawhaden, Dyfed, west Wales, enhance this craft in a beautiful and unusual way by the use of Celtic and associated designs.

Liz says that her interest in stained glass stems from her childhood. Her mother was interested in old churches, and Liz remembers that when she was young she was fascinated by the colours in stained-glass windows. She clearly remembers the opening of the 'new' Coventry Cathedral and for the first time seeing stained glass windows made using abstract designs. She visited the cathedral on a sunny day and was enthralled at the colours both in the glass and the patterns made on the floor by the reflected light.

She spent most of her teenage years in the Caribbean, and while she was there developed an interest in African art and, because of the times, psychedelic pop art. As an adult she enjoyed drawing complex black and white patterns, but whenever she tried using colour she became dissatisfied with it. From time to time she thought about attempting some stained glass, but was put off by the technical skill needed.

Like Liz, John had done a variety of different kinds of work not connected with any form of art or craft, but John had learned the craft of stained glass from his uncle. John also introduced Liz to Wales, where he had grown up, and to the art of the Celts. They were both interested in our history and especially in this ancient

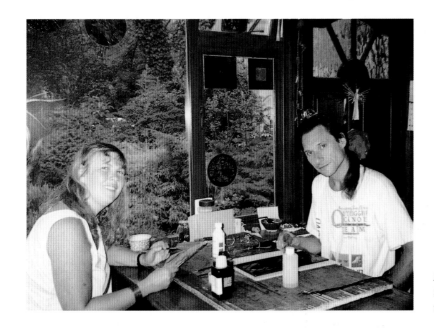

Liz and John Cawkwell in their glass-painting workshop in Llawhaden, Dyfed.

art form. John started to make small items combining Celtic patterns, which Liz would paint on to the glass, and they started to make gifts for friends, although only in a very small way. Because they wanted to use low-energy bulbs in their home, they made some tablelamps that would look good with this type of light bulb. Soon people started asking to buy their work, and, after some soul-searching, they both gave up their jobs and a few months later formed Celtic Designs on Glass.

Although they were very short of money, particularly at first, the excitement of the work made up for a lot. They made a variety of articles, such as glass roundels to hang in windows, lamps, pendants and candle shades. Every aspect of the work was carried out by hand, their only equipment being paintbrushes and a soldering iron, thus making each item unique.

Liz and John live and work on the banks of the River Cleddau, in an area that abounds with Celtic history. Three miles to the south lies the ancient town of Narberth, the seat of the court of Pwll and Riannon, whose legends are told in the *Mabinogion*. The remains of two hillforts are within walking distance of their workshop, and the village church was founded by St Aidan. They are fortunate to have to travel only a few miles to see such wonderful works of Celtic art as the Nevern and Carew Crosses,

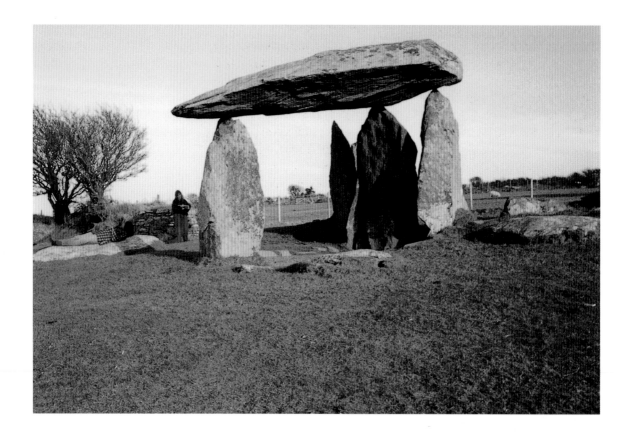

Liz Cawkwell sketching ideas for inspiration at Pentre Ifan Cromlech, close to their workshop. The capstone of the megalithic monument weighs over 40 tons.

and the environment provides material for their work. Also close by is the ancient cromlech of Pentre Ifan. This was once a covered burial chamber, but now only the upright stones and massive capstone remain. The capstone weighs over 40 tons. Radiocarbon datings show that its age is at least 4,000 years. They use both ancient Celtic designs and their own.

Glass is a beautiful medium to work in, and allows the use of vibrant colours. Many of their designs are based on stone carvings, and Liz and John try to imagine the colours that the original Celtic artists would have used. They are convinced that the Celtic carved stones were originally brightly coloured, in similar colours to the illuminated Gospels. They refer to the Gospels to help with colour, but mainly look to the rich and vibrant colours that occur in nature in Pembrokeshire, and they hope that their work captures something of this beautiful light.

Their own designs start as simple pencil sketches, often jotted down in the evening when work is finished and the children are

in bed. Liz says that ideas just come into her mind, partly, she believes, because they are surrounded by a very similar landscape to that of the ancient ones. From the initial drawing they draw the final design on card with permanent marker, and can then use this to trace the basic design onto the glass. They never see the design in colour until the glass is painted, and so the colours have to be imagined while the piece is being made. They always find it exciting to hold a piece up to the light for the first time. When Liz first started to design items for sale, she found it daunting to think that her designs would be subject to scrutiny, but the first roundel she designed proved to be (and still is) one of their best-selling roundels and this gave her a lot of confidence. They have now screen-printed that design.

Finished hand-painted glass-work, including pyramid lamps, candle lanterns and window roundels, all decorated by Liz and John Cawkwell.

The actual painting of glass is a fascinating process. They use a translucent, spirit-based paint, which is water and fade resistant but is chosen for the richness of its colour, which is almost identical to that of coloured glass. Because glass is so smooth, the paint flows over it. By varying the thickness of the paint, the intensity of colour can be varied. The colours also intermix, and beautiful effects can be achieved by applying paint and tilting the glass. Translucent marble effects can be created by blending pastel shades, and this technique can be used to produce fascinating lamps. Mixing the more vibrant colours allows intense, fiery images to be produced. Liz has used this technique to produce images of the magnificent sunsets they are so fortunate to see in West Wales.

Initially, each item they produced was unlike any other, but after a while they found that certain designs were especially popular. This was particularly true of designs based on Celtic art found in their locality, such as the Nevern and Carew Crosses and

The medieval painted tower roof in St David's Cathedral.

the Abraham Stone in St David's Cathedral. They derive much inspiration from this magnificent building, with its many Celtic associations. The design of the beautiful painted wooden ceiling of the central tower, which forms a mandala embodying an equi-armed Celtic cross, has its origins in the fifteenth century, the elaborate paintwork having been restored at a later date.

Liz and John have become aware that hand painting on glass is a time-consuming process and the paint very expensive, and this led to them spending a lot of time painting the same design and limiting the amount of time that could be spent on new ideas. It was also making some of the items costly. They enjoyed working on large pieces, using more intricate patterns, but because of the work involved, these proved too expensive for all but a few people who could afford to commission them. Both of these problems were solved when they looked into the process of screen printing.

They are now able to silk screen their most popular designs onto glass to make beautiful roundels, and they print the intricate designs onto self-cling vinyl window decals to sell for a price most people can afford. First, they try out the design by hand-painting the glass; then they mix inks to match each colour exactly. The various silk screens are then made, and each item is then individually hand-printed on glass, in the case of a roundel, or on vinyl, in the case of window decals. They have found trans-parent inks that, when carefully mixed, can produce intense hues, reminiscent of the colours of stained glass. After printing, they add a varnish to protect the ink from fading in sunlight and then apply lead to the glass roundels to create the impression of stained glass. This process produces items that are subtly different from the hand-painted work. They are intricate and the colours created are even and smooth. They are particularly magical when hung in a window, allowing sunlight to pass through them.

Now that the business is established, they consider themselves privileged to be able to spend their time working with Celtic art. Their time is taken with producing the screen-printed roundels and designing and hand-painting commissioned items. They continue to make low-energy lamps, glass oil burners for aromatherapy, as well as all kinds of decorative glass, from small roundels to full-sized windows. The craft side of their work brings them into contact with many very friendly people, while the artistic side keeps them in touch with those who lived before but who are still able to speak to us all through their work.

GRAPHICS
AND DESIGN

N THE INTRODUCTION the influence of two major figures on the revival of Celtic art in the twentieth century was noted. First, there was the pioneering work of J. Romilly Allen, and then the unique talent of George Bain was brought to bear. Bain devoted most of his life to evaluating the methods of construction of Celtic art, often working on-site with some of the finest examples of ancient stone carvings in Scotland and further afield. He was also deeply involved with the ancient illuminated Celtic Gospels, not only of Kells, Lindisfarne and Durrow, but also many lesser known ones, such as those of Armagh, St Chad and MacRegol. George Bain's work was collected after his death and compiled into one volume, *Celtic Art: The Methods of Construction*, which has now become the 'bible' of many an aspirant Celtic artist and craftworker. This book is invaluable in giving them confidence to eventually create their own original designs.

During the 1960s and 1970s a few highly talented artists emerged to give even further impetus to the Celtic art world. Names such as Jim Fitzpatrick from Ireland, Canadian-born Aidan Meehan and Alice Rigan are known to enthusiasts for their books and fine artwork. One artist stands out from this period as having made the most significant contribution to the art form. This is the Welsh-born artist Courtney Davis. Courtney's Celtic work has been well known now for over two decades, and his illustrated books, as well as paintings and prints, are renowned worldwide. His work *The Celtic Art Source Book* has been reprinted many times and has been an inspiration to many budding enthusiasts. Since then he has had a number of illustrated books published, including *The Art of Celtia*, *The Book of*

Celtic Saints, Celtic Mandalas and *Celtic Ornament*. The picture here, which incorporates the seventh-century Hunterston Brooch made from gold, silver and amber, is from the cover of his recent book with David James, *The Celtic Image*.

An illustration incorporating the seventh-century Hunterston Brooch from the cover of The Celtic Image. *Original painting by Courtney Davis.*

Today Celtic art continues to gather momentum, and some talented artists are continuing the tradition yet creating their own original styles that derive inspiration from both ancient and modern sources. One such artist is Simon Rouse, who has a studio at Oakington near Cambridge.

Simon says that he has been aware of the Arthurian legends for as long as he can remember. He knew the stories of King Arthur and the Knights of the Round Table as a child and read Malory in his teens, but it wasn't until he was in his early twenties that he discovered there was a huge Celtic world behind the legends. He was listening to the music of Alan Stivell, the great Breton harpist and composer, and was intrigued by the spiralling patterns on the record sleeves. He thinks that they reawakened something inside and, not long afterwards, he began researching into the Celts, to find out who they were and where they came from, and to try his hand at these amazing designs.

Simon Rouse at work in his studio at Oakington, near Cambridge.

Celtic artwork by Simon Rouse.

He read everything he could find and, while looking through one of the local bookshop's Celtic studies section, found George Bain's book, which, says Simon, was a revelation and an invaluable aid in getting him started on his own designs. He had always dabbled in art, but until he found that Celtic connection, he had no focus. He found that having these intricate patterns laid out and explained in one book was marvellous. The more he read, the more he became immersed in the Celtic world, finding the whole culture of the Celts fascinating and romantic, although tinged with a harsh reality.

The longevity of the Celtic art form itself, is, thinks Simon, astounding, especially when it is realized that so many of the patterns have remained unchanged for the centuries. He became enchanted with the interlaced designs, and so began his journey into the realms of Celtic art. Around this time he also came across the artwork of Courtney Davis, whose work inspired him further to produce his own original designs.

Since the early days, Simon has been producing nothing but Celtic art, and it is, he says, very much like an inner calling. It has become an endless fascination for him, and he cannot foresee a time when he won't be involved in Celtic art. Some of his early designs were published in the journals of the Pendragon Society,

the long-established Arthurian society, and it was through the encouragement and good offices of the society's editors that he found a regular outlet for his work. The relationship has continued to this day, and he still provides the cover art for *Pendragon*, doing three or four covers a year, each one illustrating the particular theme of that journal. During this time, too, he started to receive commissions for his work and this further encouraged him to find other outlets for his designs. He offered some artwork to David James at *Celtic Connections* magazine, and this opened up more opportunities to work on other people's projects and brought him into contact with other like-minded people, some of whom have provided a great deal of inspiration through their own writings and artwork.

As well as producing these various black and white illustrations for magazines, Simon started to add colour to his work, and the designs became bigger and evolved into paintings. He acquired some books about the great illuminated manuscripts of Celtic art, including the Book of Kells and the Lindisfarne Gospels, and was amazed at the intricacies of the designs on the pages of these books and the skill with which they were executed. These marvellous works of art gave him a true idea of what could be attained within this tradition and his admiration for the monks who created these works grew each time he opened the books. When, a couple of years later, he was lucky enough to see the original Book of Kells in the Library of Trinity College, Dublin, he was amazed that the colours on the pages were so fresh and vibrant over one thousand years after they were first created. His sense of wonder at these works and the other manuscripts he has since discovered has grown over the years, although he now feels it would take several lifetimes to achieve a fraction of what is contained within these books, such is their glorious interpretation of the word of God.

Opposite: The cover artwork for Pendragon *magazine, by Simon Rouse.*

He exhibited four of his paintings of four Celtic maze designs at the Labyrinth '91 conference at Saffron Walden, Essex. Having one's work publicly judged for the first time is a rather unsettling experience, but the response to Simon's work was generally good. A commission he found especially exciting was to design a logo for a new Celtic garden situated at Llanberis, in Snowdonia, north Wales. The garden was built to represent the Celts' relationship with nature, in all its many forms, and this provided him with a great deal of inspiration for the designs, which were used on promotional literature and signs around the garden. There are

many natural forms within Celtic art – the various knotwork patterns themselves have a very organic feel and the zoomorphic imagery is great fun to play around with – and some of these natural forms are represented in one of his latest paintings.

Capall Bann Publishing had seen one of Simon's designs of a Celtic cross and thought it would make a good cover for a book about paganism and Celtic Christianity. This led to his doing

Painting using Celtic motifs, including knotwork, by Simon Rouse.

THE WHOLE OF CREATION IS THE LANGUAGE OF GOD

more covers for them, and his current project is illustrating a book on Celtic animals. Llanerch Publishers in Dyfed, South Wales, also started to use his designs on a number of their Celtic and Arthurian books, with the exciting prospect of also being published in America. With most of the commissions he receives, Simon is lucky in that he usually has a free hand in interpreting the client's wishes, only occasionally having strict guidelines to follow. He finds it more rewarding to work freely, because this often results in a more pleasing and balanced design. He begins by attuning himself to the project at hand, sometimes doing a little meditation and gathering any ideas the client may have along with his own thoughts on what form the design may take. Nothing is definite at this stage – he waits for the patterns to emerge in their own time. He is conscious of working within a tradition that is thousands of years old and of all the great Celtic artists who have gone before him, so he tries not to rush this important first stage.

At times it seems to Simon that there are higher powers at work. The patterns and designs can become so involved that it is sometimes easy to become lost in them, and it is only when the painting or illustration is finished and he steps back that he can really see what has evolved. It's very important to him to be able to work in this way. A forced design has no balance or rhythm, no spirit, and most of these end up in the waste bin. He does keep one or two though, reminders not to let his pen take a journey down that path. He works with pencil and drawing pen on smooth ivory card for black and white work and with gouache on parchment paper for paintings, which gives them a good manuscript feel.

Much of Simon's inspiration comes from the ancient and sacred sites he has visited throughout Britain and Ireland over the years. Places like Avebury and Castlerigg stone circles and Glastonbury have drawn him back many times. Each site has its own special power, and the excitement of visiting an ancient site, especially for the first time, is something he looks forward to. He believes that if we are to make sense of the future, we must understand the past, and making these pilgrimages to ancient sites of worship helps us to begin to understand how our ancestors lived and how they viewed the world around them. They left their mark on the world but they left it harmoniously, something, Simon feels, we could well do to remember in this modern world of concrete and pollution.

Simon lives in an area that has not been regarded as Celtic for many centuries, for the remaining physical evidence of a Celtic population is small, most of their settlements and sites having gone under the plough. Still evident, however, is Wandlebury hillfort on the crest of the Gog Magog hills just to the south of the city of Cambridge. It has its origins in the Iron Age and was situated to overlook the Icknield Way, a major trade and communications route from the West Country to Norfolk. Although on a hill, the fort is easily accessible and so was probably strongly defended. It has undergone many changes over the years, the inner ring having been heavily landscaped during the eighteenth century, when gardens, stables and a mansion house were erected. The surrounding area has seen extensive tree planting, but for all this, the site still has a certain magic at any time of year. For centuries legends have been attached to the Gogs giant figures, which are cut into the chalk on the slopes close to the ring.

The massive ditch and rampart of Wandlebury Ring Iron Age hillfort.

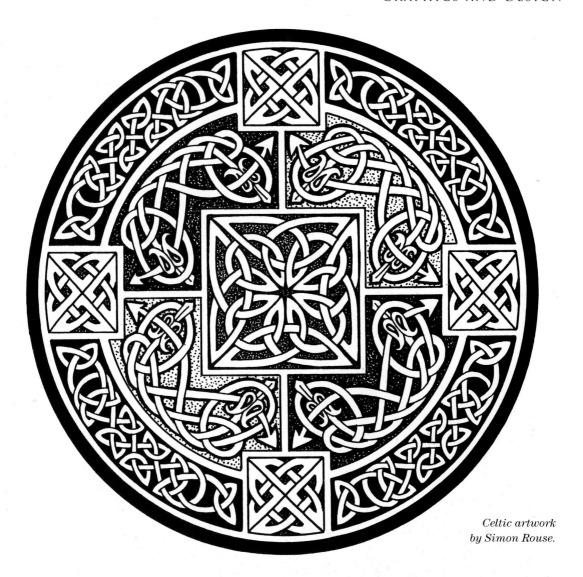

*Celtic artwork
by Simon Rouse.*

Between 1954 and 1956 T.C. Lethbridge excavated an area to the
southwest of the fort and discovered what he believed to be the
figures of a giantess and a horse, possibly a representation of the
Celtic horse-goddess Epona. Lethbridge's discoveries found little
favour among archaeologists and academics at the time, but his
theory remains an intriguing possibility. He also believed there
were two other giants waiting to be uncovered, one of which was
a Celtic god figure wearing a torque and holding a sword and
small shield. The traces of his excavations can still be seen if you
look hard enough.

Jen Delyth at work in her garden in San Francisco, California, in 1966.

As we approach a new millennium, the Celtic identity is strong. People everywhere are awakening to and embracing their heritage and rediscovering what it means to be Celts. Nowhere is this more apparent than in the arts, and the future for Celtic art looks bright. There are more artists and crafts-people now than there have been for many years, and the continuation of the tradition looks assured. We, the current practitioners of this art, have a two-fold duty: to continue to use the old patterns and keep them alive, and to develop fresh, new designs that will provide future gener-ations of Celtic artists with a larger store of source materials from which to work. It is a living legacy that will continue as long as Celts walk the earth.

Interest in and the practice of Celtic crafts today is not confined to the Celtic countries, and it seems appropriate to include details of dedicated Celtic craftwork being carried out further afield. One such craftworker is Welsh-born Jen Delyth, who has been living and working in California for the last decade and inspiring people in the New World with her fine work. Her crafts business Keltic Design is run from her studio in San Francisco.

Jen works with traditional Celtic design in several media, including painting, illustration, silk screening onto textiles and, recently, working with silver. She started her Keltic Designs crafts business eight years ago in California, where she had moved in the mid-1980s. Her family, who still live in Wales, sell her work at local fairs and conventions, keeping her life and business truly international.

Her first interest in Celtic mythology was inspired by her mother, who grew up closely

'Triskelion, the Triple Goddess'; an original design and screen print by Jen Delyth.

connected with Welsh folk tradition, through her involvement with the youth Urdd movement and singing Welsh folk songs, which Jen later also enjoyed. Jen remembers hearing her mother recite parts of the *Mabinogion* that she had learned in school, and although Jen didn't understand the words, she knew that this was really special.

Jen's work in Keltic Designs – spelt with a strong, older letter K, which is the original spelling of Keltoi, before the Romanized letter C came to be used – is inspired by the folk motifs and symbols of the ancient Celts, interwoven through her own experiences and vision as a twentieth-century person. Jen believes that it is essential to contribute to the evolving nature of the living folk arts both by learning and working with designs of the crafts people of the past, and by integrating new ideas and styles, which allow personal interpretation to show through and give the work relevance today.

Jen has always enjoyed working with her hands, as well as learning the patterning of the images and folklore. It was her interest in the language of symbols that led her to become a self-taught artist. Creating designs that express essential Celtic arche-types gives her satisfaction by involving both the discipline of form and the challenge of integrating concepts and ideas. At first she explored the mandala circular form, focusing on combina-tions of threes and nines, the numbers of the Celtic female prin-ciple. The circle is organic, without beginning or end, and is the symbol of the goddess. A circular mandala frequently refers to the cyclic view of life, nature, fate and time, and mandalas are tradi-tionally symbolic diagrams, often used for religious contempla-tion. For Jen, this was the intuitive choice, and she found it especially inspiring while she was working with Celtic knotwork designs. She also enjoyed using only black and white to express the central balancing principles of light and dark, intricacy and simplicity, mystery and clarity – ancient lines with a contempo-rary expression.

'Keltic Mandala', original design and screen print by Jen Delyth.

At first Jen concentrated on the Celtic goddesses, who, although rarely depicted in ancient Celtic design for reasons of respect, form the heart of Celtic spiritu-ality. Arianrhod, Rhiannon, Blodeuwedd and Cerridwen from the *Mabinogion* were natural subjects. She also chose the spirals, triskeles and labyrinth (key-knot) motifs that are the organic patternings most closely related to the female earth-centred ancient world. *Tree of Life* was one of her first original designs, and this symbol, common to many world cultures, is a good example of an archetypal image and is especially relevant to the old Celtic religion.

Jen found the process of learning to silk screen images onto paper, creating serigraphs and producing limited runs of prints fascinating. An ancient Japanese art, silk-screening techniques were rediscovered in California in the 1950s as an exciting way to work with images, and it soon gathered a strong following of artists. There is a print-making community in San Francisco, who are experimenting,

creating prints, signing and matting small editions, each one an original in a way.

Each of Jen's crafted designs is accompanied by an explanation of the symbolism and mythology, which she carefully researches and explores before publication. She hopes that her designs will communicate without words, but the stories and explanations behind the work are really important to her.

Jen and her husband, Scott, wanted to find a living that allowed them time and space for their creative pursuits, and decided to sell her work at local crafts fairs in the United States. Keltic Designs received a positive response, and soon they were travelling all over the country, meeting other people who were passionate in their love of Celtic art, philosophy and spirituality as themselves. It didn't take them long to realize that America is, in many ways, the adopted sister of the modern Celtic nations. This is partly, of course, because a large proportion of European Americans are immigrants from Ireland, Scotland, Wales, Cornwall, Brittany and the Isle of Man, who, seeking a life free from poverty, religious and political persecution, continued their historical westward movement to America. They took with them their traditions, their music and their stories, and the Celtic spirit is still fertile in communities that grew up retaining the elements of their cultural past.

Through their flourishing crafts business, Scott and Jen discovered an amazing community of Celtic gatherings where it is not unusual to find from 10,000 to 50,000 people at a single event. An extraordinary number of people come to renew and celebrate their heritage at Irish music festivals. Scottish dance and game competitions feature pipe and drum bands, who proudly display their clan tartans and costumes, while Scottish-Americans toss the caber and compete in serious dancing trials. Welsh-American eisteddfods are held regularly, and many Americans are learning to speak the Welsh language fluently. The Celtic traditional arts and crafts draw together all those who recently left their homelands, along with those who have traced their families immigration through their grandparents, great grandparents and those who could find their ancestors arriving on the *Mayflower*.

CELTIC CRAFTS AROUND THE WORLD

ANY YEARS AGO, and for various reasons – mostly ones imposed on them by political action, persecution and poverty – people from the Celtic countries were forced to emigrate from their homelands to diverse parts of the world. Subsequently, groups and societies with the Celtic tradition as their common bond emerged and have been flourishing in countries as diverse as Patagonia, at the tip of South America (where there is a strong Welsh-speaking population) to New Zealand, Canada, the United States and many lands in between.

An integral part of the Celtic tradition is craftwork, which has enjoyed a tremendous upsurge in recent years. The nostalgia that follows the leaving of any of the wild and beautiful Celtic countries has to be experienced to appreciate the intensity of this feeling – this is partly why so many settlers in the new countries named their towns after counterparts in their native lands and also why today many of the ancestors of these settlers long to return to their roots and visit their Celtic homelands to see the wonderful landscapes and experience magical atmospheres for themselves.

New Zealand, for example, has a number of Celtic-orientated societies, one of which has links with the Scottish islands. The members of one of these have built on their own land an exact reconstruction of the Ring of Brodgar, a stone circle on the Orkneys. This feat is a craft in itself – they carved the stones to the precise proportions and erected them in the exact positions to

'Bridie', painting by Shigeko Takenaka.

correspond to the original circle. Some of us who live closer to these precious ancient sites may find this idea a little strange, but if you live on the other side of the world and one of the most meaningful places in your life is a Bronze Age stone circle on a Scottish island, what better way to be reminded of it than to build your own version.

Nearer to home, Celtic crafts being carried out in most of the European countries, either in conjunction with a continuation of unbroken Celtic tradition, as in Brittany for example, or alongside a revival of Celtic culture such as is being rediscovered from the La Tène era. This interest is emerging strongly in Italy and Spain, where there are magazines devoted to Celtic culture and crafts as well as workshops and shops producing and selling craftwork. In Switzerland the annual Celtic Days at Lake Constance festival is attended by enthusiasts from around the world, and it incorporates Celtic music, craftwork and workshops making musical instruments.

The large annual festivals in Brittany, such as the ones at Quimper and L'Orient, are very well attended and have excellent sections devoted to Breton craftwork as well as to Celtic craftwork from other countries. The pioneering work of the harpist Alan Stivell means that there are now not only a number of very fine Breton harpists but several harp workshops where the tradition of harp making is continued.

Most other European countries have practitioners of some form of Celtic crafts, from instrument making to the creation of fine jewellery from both the La Tène and Celtic Christian eras. There are, for example, a silver engraving workshop in Enschede, the Netherlands, and a pottery studio in Vailly-sur-Sauldre, France. The fine Celtic artist Shigeko Takenaka lives in Japan. Whenever possible she returns to her favourite Celtic environment, the Scottish islands, to find inspiration for further work.

No doubt there are other talented practitioners of Celtic crafts in other parts of the world, but this brief summary will give at least some idea of the worldwide resurgence of Celtic crafts and culture.

Calendar produced by Keltria Editrice, Italy.

FURTHER READING

Backhouse, Janet, *The Lindisfarne Gospels*, Phaidon Press, London, 1981

Bain, George, *Celtic Art: The Methods of Construction*, William MacLellan, 1951 (Constable, London, seventeenth impression, 1994)

Davis, Courtney, *The Celtic Art Source Book*, Blandford, London, 1988

Davis, Courtney, *The Art of Celtia*, Blandford, London, 1993

Davis, Courtney, *The Book of Celtic Saints*, Blandford, London, 1995

Davis, Courtney, *Celtic Mandalas*, Blandford, London, 1993

Davis, Courtney, *Celtic Ornament*, Blandford, London, 1996

Evans Wentz, W.Y., *The Fairy Faith in Celtic Countries*, 1911 (reprinted Colin Smythe Ltd, Gerrards Cross, Bucks, 1977)

Giraldus Cambrensis (Gerald of Wales), *Topographia Hiberniae (Travels Through Ireland)*, c.1188, trans. John O'Meara, Penguin Books, Harmondsworth, 1982

James, David, *The Carved Stones of Western Scotland*, Thule Press, Isle of Lewis, 1978

James, David, and Davis, Courtney, *The Celtic Image*, Blandford, London, 1996

James, David, and Bostock, Simant, *Celtic Connections: The Ancient Celts, Their Tradition and Living Legacy*, Blandford, London, 1996

Kermode, P. M.C., *The Manx Crosses*, Bemrose & Sons Ltd, London and Derby, 1907

Langdon, Andrew, *Stone Crosses in East Cornwall*, Cornish Cross Series no. 3, The Federation of Old Cornwall Societies, 1996

Lines, Marianna, *Sacred Stones, Sacred Places: An Illustrated History of Pictish Sites*, Saint Andrew Press, Edinburgh, 1993

Richards, Maureen Costain, *The Manx Crosses Illuminated*, Croshag Publications, Isle of Man, 1988 (available from Ballabrara Arts, Port St Mary, Isle of Man IM9 5DA)

Romilly Allen, J., *Celtic Art in Pagan and Christian Times*, 1904 (reprinted Bracken Books, London, 1993)

Severin, Tim, *The Brendan Voyage*, Hutchinson, London, 1978

Stevens, George, *The Irish Harp, Its History, Players and Techniques* (available from 31 Bar Terrace, Falmouth, Cornwall)

Young, Susan (ed.), *The Work of Angels*, British Museum Publications, London, 1989

JOURNALS

Celtic Connections

This quarterly magazine covers Celtic and related subjects, craft-work and history from all the Celtic countries. The book, *Celtic Connections*, published by Blandford, incorporates material from the first four years of the journal and follows the story of the Celts from their earliest known European origins through the present Celtic renaissance. For details contact: David James, Sycamore Cottage, Waddon, Portesham, Weymouth, Dorset DT3 4ER

Sounding Strings

One of the best magazines devoted to the Celtic harp. For details contact: Burnlea Cottage, Bridgecastle, Bathgate, West Lothian, Scotland EH48 3DP

DIRECTORY OF CRAFTWORKERS

Readers who would like further details of the Celtic craftworkers featured in this book can contact them at the addresses given below.

Goldwork

Rhiannon Evans, The Welsh Gold Centre, Tregaron, Ceredigion, Wales SY25 6JL (tel: 01974 298415; fax: 01974 298690)

In addition to her own exquisite gold jewellery designs, Rhiannon now produces a selection of Celtic heritage craft items and also creates commissions for a wide variety of people and occasions.

Silverwork

John Hart, Hebridean Jewellery, Garrieganichy, Iochdar, South Uist, Western Isles HS8 5QX (tel: 01870 610288; fax: 01870 610370)

Shop at: 95 High Street, Fort William, Highland, Scotland PH33 6DG Colour catalogue of jewellery available; commissions undertaken for high-quality Celtic silverwork.

Pete and Jane Rowland, Hrossey Silver, Crumbecks, Orphir, Orkney Isles KW17 2RE (tel and fax: 01856 811347)

Colour·catalogue of jewellery available; commissions undertaken for individual silverwork; high-quality stylized Celtic, Viking and naturalistic designs.

Pewterwork

J.J. and H.J. Cockram, Piran Pewter Company, Padstow Old Forge, Old Station Yard, Padstow, Cornwall PL28 8BW (tel and fax: 01841 532709)

Shop at: The Cave, Mill Road, Padstow, Cornwall
Wide range of high-quality pewterwork available, including miniature Cornish crosses; details on request.

Enamelwork

Christine Forsyth, 33 Albury Place, Aberdeen AB1 2TQ (tel: 01224 582660)

Brochure of designs available; high-quality enamelwork; silver and goldwork by commission only.

General Sculpture

Simant Bostock, Spirit of the Ancestors, 24 Northload Street, Glastonbury, Somerset BA6 9JJ (tel: 01458 833 267)

Wide range of quality Celtic sculptures from goddesses to power animals and Celtic crosses; commissions for larger works accepted; comprehensive photographic library of Megalithic sites, from Holland to the Outer Hebrides; catalogue available; enquiries/commissions accepted for photographs for use in publications.

Miniature Pictish Carvings

James Gillon-Fergusson, 11 Cleghorn Street, Dundee, Tayside DD2 2NQ (tel: 01382 645738)

Highly detailed miniature replicas of early Pictish carved stones from northern and eastern Scotland; illustrated catalogue available.

Woodcarving

Mike Davies Welsh Lovespoons, Andersea, Broadway Hill, Norton, near Ilminster, Somerset TA19 9QR (tel: 01460 55232)

Master carver of Welsh lovespoons; illustrated colour booklet of the history of the lovespoon, with pictures of some major commissions over the last thirty years; send £2.50 (inc. post and packing) to above address; commissions accepted.

Allen G. Calvin, 78 Sixth Street, Midland, Ontario, Canada
L4R 3X2 (tel: 705 526 0629)

High-quality wood sculptures related to Celtic subjects; commissions undertaken to individual specifications; enquiries welcome.

Slate Carving

Maureen Costain Richards, R.V. B., Ballabrara Arts,
2 The Promenade, Port St Mary, Isle of Man IM9 5DA
(tel: 01624 832656)

Craft shop displaying and selling Manx slate carvings and other Manx craftwork; author/illustrator of the only book on Celtic/Viking crosses on the Isle of Man, available from above address.

Musical Instrument Making

Malachy and Anne Kearns, Roundstone Musical Instruments
Ltd, Roundstone, County Galway, Republic of Ireland
(tel: 095 35875; fax: 095 35980)

Makers of bodhrans for over twenty years; hand-made bodhrans of all sizes available; also made and decorated to specification; supplied worldwide, including to many well-known Celtic bands, including the Chieftains and Planxty; colour brochures and details available.

Joël Garnier and Jakez François, Camac Production,
La Richerais, B.P. 15–44580 Mouzeil, France
(tel: (33) 40 97 24 97; fax: (33) 40 97 79 31)

Specialist makers of traditional Breton instruments (predominantly harps); quality Celtic harps of various designs; also larger concert harps; colour catalogues and details available.

Pottery

James P. Murray, Glenarm Pottery, 26 Altmore Street, Glenarm,
County Antrim, Northern Ireland BT44 0AR

Commissions undertaken for finely detailed bowls and plates with elaborate hand-engraved Celtic designs; also unique Celtic pottery designed to specification.

Leatherwork

Sue and Iain Gunn, Celtic Leather, Argyle Street, Ullapool, Wester Ross, Highland IV26 2UT (tel and fax: 01854 612689)

Shop at: 52 High Street, Royal Mile, Edinburgh EH1 1TB
High-quality functional and decorative leather craftwork incorporating Celtic designs; shop, workshop and gallery with other Celtic craftwork on display and for sales; commissions accepted.

Justin Capp, Epona Craft, Barkston, Thurning, Peterborough, Northamptonshire PE88 5RB (tel: 01832 293330)

Unusual hand-tooled, high-quality leather masks based on Celtic gods, power animals, birds, horses, etc. from the pre-Christian era; commissions undertaken; details leaflets available.

Beadwork

Annie Wealleans, Celtix, Black Dragon Crafts, Bryn Talog, Pencader, Dyfed, Wales SA39 9BD (tel and fax: 01559 384624)

Beautiful range of beads engraved with intricate Celtic knots and finished in antiqued silver plate; supplied singly, drilled with 3mm holes or as finished chokers, bangles, etc.; some also combined with semi-precious stones; colour leaflet available.

Stained Glass

Gary Smith, Celestial Glass Stained Glass Studio, 9 East Terrace, South Queensferry, West Lothian EH30 9HS (tel: 0131 331 4553)

Shop at: Mosaic, 8 East Terrace, South Queensferry, West Lothian
High-quality, leaded stained glass with Celtic themes incorporated; commissions accepted; community projects welcomed.

Glass Engraving

Lynn Berry, 4 Rheast Mooar Avenue, Ramsey, Isle of Man

Fine-quality glass engraving, incorporating ancient Manx designs; commissions accepted from personal visitors only.

Hand-painted Glass

Liz and John Cawkwell, Celtic Designs on Glass, Mountain
View, Llawhaden, Dyfed, Wales SA67 8DJ (tel: 01437 541306)

Hand-crafted and hand-painted materials using high-quality
materials; items made to individual specification; new range of
screen-printed designs; catalogue available.

Graphics and Design

Courtney Davis, Awen, 3 Rodden Row, Abbotsbury, Dorset,
DT3 4JL (tel and fax: 01305 871828)

Books and artwork are available worldwide; full details of publi-
cations are available from Blandford, Wellington House, 125
Strand, London WC2R 0BB (tel: 0171 420 5555; fax: 0171 240
7261).

Simon Rouse, The Light of Celtia, 43 Water Lane, Oakington,
Cambridge CB4 5AL (tel: 01223 233386)

Commissions undertaken for book covers and illustrations,
magazine illustrations, etc., in colour and black and white; origi-
nal paintings connected with Celtic and Arthurian themes
complete to specification.

Jen Delyth, Keltic Designs, 554 Third Avenue, San Francisco,
California 94118 (tel: 415 664 0204 or 800 346 2358;
fax: 415 668 2321)

Mail order: Dryad Graphics, Lower Mill Cottage, Hill End,
Llangennith, Gower, Swansea, West Glamorgan SA3 1HU

Stationery, cards, paintings, screen-printed clothing and silks, etc.

USEFUL
ADDRESSES

Celtic Coinage

Chris Rudd, PO Box 222, Aylsham, Norfolk NR11 6TY
 (tel: 01263 735007; fax: 01263 731777)

Chris, who supplied the photograph of the Tasciovanus gold stater on page 12, produces a regular catalogue of Celtic coins for purchase. The booklet, which is updated regularly, contains historical information and photographs of coins.

Harp Kits

These are available from: Hobgoblin Musical Instruments, 17 The Parade, Northgate, Crawley, Sussex RH10 2DT

Celtic Days at Lake Constance

The annual Celtic festival is held at Rorschach. For details contact: Kora Wüthier, Bahnplatz 7, CH–9400 Rorschach, Switzerland.

Celtic Books and Publications in Italy

Keltria Editrice Ltd, rue du Bailliage 5, PO Box 212,
 11100 Aosta, Italy

Books, calendars, artwork, quarterly magazine; quality publications in Italian on Celtic history, coinage, sites, etc.

INDEX